ABSTRACT & SURREALIST ART IN AMERICA

SIDNEY JANIS

ABSTRACT

&

SURREALIST

ART IN AMERICA

REYNAL & HITCHCOCK, NEW YORK

To my sons

Conrad and Carroll

INTRODUCTION

IT IS virtually axiomatic that vital thought in any epoch can advance only by means of a cultural spearhead or vanguard. Yesterday's vanguard art is traditional today. Today's, just entering its second generation, has the drive and spirit of youth; it is still in process of growth and change. The virility of its two main trends, abstractionism and surrealism, demonstrates that these have particular meaning for rapidly increasing numbers of our artists and that appreciation on the part of the public goes apace. For in the thirty years since the famous "Armory show," the handful of vanguard artists has multiplied in number, until today there is a nationwide practise of and interest in these dynamic trends.

This survey, extended over a period of seven years, presents a cross section to give a composite and living picture of the work being done in America. From various sections of the country, veteran painters and the young and in some cases those not yet widely known, participate in this cultural revaluation.

While abstract artists have been active here since 1913 and surrealists for a dozen years, no book has yet dealt exclusively with the one or even touched upon the other. In view of the activity in this country, this seems strange, especially if one considers that books on cubism were published in several languages almost at its inception, at a time when it was highly controversial.

In order to place American abstract and surrealist art against its proper background, it has been found necessary to review parent art movements abroad. A brief account of advance trends in European painting, entitled "Sources in Twentieth-Century European Painting," therefore precedes the chapters on the work of the American artists. While the new vision originated abroad, its validity as an international esthetic is attested by the rich yield in the work of our artists, as well as by the vigor of the artists in exile in our midst, who are represented in their American work. Limitation of space makes it impossible to discuss many artists worthy of inclusion.

Since the term modern art is so all-embracing, a distinction has been made between contemporary works that adhere to the past and the works of painters of the advance guard. If one group is accepted as modern, then the other, because it explores the complex structure and ideology of its time in terms consistent with its nature, may truly be called twentieth-century art. The references that follow are based accordingly.

The text is confined to twentieth-century painting, and nineteenth-century painting and literary influences have not been touched upon; neither have vanguard literary movements, although these were significant, especially in futurism, dadaism and surrealism.

Contemporary achievements in sculpture, architecture, industrial design, typography, book design and photography, because they do not come within the scope of the present survey, are also omitted. Since these have been strongly affected by twentieth-century painting, it might be considered imperative that a book dealing with sources having so profound an influence, should utilize the new ideas by a form of presentation equally as progressive. To this end, the introduction of visual language to supplant the printed word as far as possible, would be desirable. War restrictions make such a project unfeasible at this time.

The author wishes to thank those who graciously helped in assembling the material; those who

kindly allowed reproduction of paintings from their collections; those who loaned photographs of paintings for use in the book; those who consented to the use of quotations from various publications, and especially the artists who contributed to the book in words as well as work, to all of whom credit has been given in the text. I also want to thank Mr. Lawrence H. Lipskin for his editorial help, and above all, I am indebted to my wife, Hansi, for her invaluable counsel and assistance.

CONTENTS

*As nearly as possible, the plates occur in the order of the artists' appearance in the text.

1 SOURCES IN TWENTIETH-CENTURY EUROPEAN PAINTING

SCIENCE is the open sesame of twentieth-century art, and artists have entered where angels fear to tread. With the wonder of children and the wisdom of the universe they have investigated, analyzed, dissected, uncovered, painted, pasted and constructed in the process of creating the visual counterpart of the anatomy and structure and inner spirit of the time in which they live — the *new realities* of the twentieth century. From the start the whole purpose of painting has been re-examined with scientific precision reaching in several directions and carrying over from one painter to another, from one painting movement to another.

The most important artists of our time are from many countries, and while Paris was the nurturing mother, many painters have developed at home, sometimes in isolation, or moved to foreign lands without a break in the progress of their work. They have appeared everywhere because in this emergence of the innate culture of our era, national borders are of minor moment.

The development of man's visual conception as a basis of artistic activity has gone forward in the twentieth century with a tempo true to the pulse of this highly accelerated period. In an epoch throbbing with the vitality and rhythms of a new spirit, a time of courageous exploration and rewarding discovery, perceptive faculties could hardly do otherwise, perhaps, than make a proper and consistent response to the force of the age. However that may be, the fact remains that with the opening up of vast new fields in science, the imagination of the artist has responded deeply to the methods and scope involved. That is why, to participate in today's culture, it is only necessary that a country be infused with modernization of its physical equipment. Focusing points both large and small reflect this fact like a kaleidoscope throughout the transpositions found in art.

Just what is twentieth-century art? Dada, *collage, de Stijl,* the cubists, automatism, the constructivists, surrealism — what have they given us? Let us see. Our starting point is the point of view of science.

The parent impulse came from the French art of impressionism with the breaking up of light, and from Cézanne with the geometric postulate of the cube, the cone and the cylinder. Cubism discloses its joint heritage with the breaking up or dissection, not of light this time, but of the object; and in the geometric physiognomy of its pictures. Achievements here were not the result of mathematical formulae but of ideas which were transmuted through creative processes.

Collage (pasting), the second step in cubism, was a search for new methods and materials which, in employing new techniques, conditioned subsequent findings, to say nothing of its contribution to subsequent philosophic points of view in painting and to the poetry of painting.

Futurism was replete with scientific attitudes. It emerged from the neo-impressionist breaking of light and from the cubist breaking of form. Adding kinetics, it utilized pictorially the progression and velocity of movement, dynamic tensions, lines of force and other concepts which devolve from the analysis of matter in general.

The various categories of nonrepresentational, or rather nonfigurative painting, dedicate themselves to pure, abstract values. Though these are conceived within the province of esthetics, the laws of physics

are frequently the instruments for determining plastic variations such as the degree and kind of equilibrium used for space or color.

Principles of *collage* as well as other facets of twentieth-century painting provided the means, both imaginative and mechanical, for dada invention — that ingenious and diabolic procedure which, aiming solely at destruction of all existing values, confounded its own disciples by being constructive.

Surrealism at a quick glance seems farthest removed from science. Still it has consistently made an ordered, scientific attempt to release the creative impulse, mainly through its adaptation of psychoanalytic techniques and especially through a system of tapping the resources of the unconscious.

It is evident even from this cursory summary that the scientific background of modern life is reflected in the two most dynamic directions in twentieth-century painting, the abstract and surrealist movements. This is even more apparent if the psychological, philosophical, social and moral factors and pictorial syntheses are brought under consideration.

These two antithetic directions, abstract and surrealist, are allied to undercurrents of opposing traditions which have persisted for centuries and which, though radically changed, continue today. One may be regarded as romantic, and in general follows from fauvism through expressionism, joining in the formation of the surrealist stream. It may be emotional, intuitive, spontaneous, subjective, unconscious. The other, following the classic line, stems from cubism through futurism to abstract art and is for the most part intellectual, disciplined, architectonic, objective, conscious.

Because of the expanding horizons of the art of our time, few specific twentieth-century movements or modern artists can be held strictly within one category or the other. Opposing tendencies as well as the overlapping and intermingling of both may be found within the same painting movement. The artist himself may swing on occasion from the extreme of one to the extreme of the other or even — difficult though this seem — embrace both directions within the same work.

Since from its inception cubism dominated the scene, it might appear that the classic tradition has consistently held sway. But the bold, vigorous fauvist freedom, of which Matisse was the innovator, opened the twentieth century on a romantic note. After fauvism had reached its apotheosis in 1907, the romantic trend went into eclipse, to reappear intermittently until it came into prominence again with the advent of surrealism twenty years ago. To this day it retains its position on a level with that of classicism, a duality that is seen to have asserted itself both in painting movements and in the work of individual artists.

In technique the *fauves* employed strokes of brilliant cacophonous coloration which, though related to the nervous streamers of the post-impressionist Van Gogh, were neither agitated nor tortuous, but extremely confident and free. Juxtaposed to these vibrating passages and divided by black outlines were highly colored broad areas derived from Gauguin. The *fauves*, whose members included Matisse, Braque, Derain, Dufy, Vlaminck, Friesz, succeeded at their best in supercharging their canvases with a delirious lyricism.

Following in the same tradition, the next movement, German expressionism, also had its taproots in Van Gogh and Gauguin, but its more abstractly expressive side sprang from *fauve* sources. Outstanding among expressionist works are the imaginative improvisations of Kandinsky, who incorporated *fauve* color ideas in his spontaneous art of 1912-14 (5).* These pictures of pure sensibility anticipated by more than a dozen years the automatist technique which provided the initial stimulus to surrealist art.

Other inspired precursors of surrealism were Chirico, whose inner eye first registered the oblique light of his arcaded silent cities in 1911; Chagall, who in the same year began to paint Russian folklore in a phantasmagoric and weightless world; Duchamp, whose casually conceived works in 1913 were,

* Plate number of reproduction.

anomalously, instruments of precision and of chance; and Klee, whose imaginative linear fantasy began to unfold not much later.

In the years preceding the first World War, there was hardly an interval in which some new art form or personality did not burst upon the European scene. The period was rampant with revolutionary ideas, fervid group activity and dramatic achievement. The war itself seriously disrupted this activity. Painters of the war generation had to stand by while their powers of concentration and their skills were assailed. After the peace, while many of the artists had lost much personal vigor, the development of ideas within group movements was again of great vitality. Some of the artists did not regain their individual powers until, again dislocated by war, they came here as exiles. But even so cataclysmic a threat to art as war may be neutralized. The marshaling of talent, however academic, during World War II by various governments for the purpose of employing it and sustaining the function it had established in relation to the community constitutes an attempt to keep intact the cultural values of art. And again, not one country but several support this program just as their artists share the sources of inspiration of the age.

The painting movements which followed each other from cubism through surrealism will be touched upon briefly in some of their pivotal points to indicate the progression that furnished the background for American abstract and surrealist painting.

In the formative years of cubism, 1906-09, the Spaniard Picasso painted under the strong impact of African Negro art. His Iberian background possibly furnished the insight with which he evaluated its primitive qualities and transmuted them into contemporary esthetic terms. The turn toward primitive art was apparently the result of scientific interest in cultures other than our own. African Negro art, while its role in twentieth-century painting was considerable, made its entrance casually. Recognition of its esthetic had fallen to members of the *fauve* group, but they found it merely of passing interest, introducing suggestions from it in their painting and these only occasionally.

On the other hand, primitive influences proved to be a powerful directive throughout the evolution of early cubist principles. The archaic forms and structure of Negro art furnished a clue to the presence of parallels in Cézanne's work, and the merging of these corresponding elements helped to formulate the facet technique characteristic of early cubism. Soon Picasso was joined by Braque, who had abandoned fauvism, and pooling their ideas, they worked for the same objectives so intently that for a time anonymity seemed a virtue and they did not sign their pictures. By 1910-12, the heroic epoch of analytical cubism, the work of Picasso, Braque and their followers entered its most spiritual and complex phase of development (1, 2).

In Cézanne the cubists found an endless magic touchstone, the variety of which they infused in their early work. Devoting the last years of his life (1895-1906) to spatial problems, Cézanne had begun to overturn laws of deep space in acceptance since the Renaissance. This was a long step toward freeing art from the shackles of the past. His hatching-like brushstrokes, derived earlier from Pissarro, now became freer and were structurally integrated into the pictorial design of his paintings. This enabled Cézanne to relate foreground forms more closely with background, effectively reducing deep space. Cubism converted the color hatchings into facets similar to the rhythmic planes in African sculpture, and the appearance of these facets equally in background and foreground brought them into even closer relationship. Accentuating more and more the flatness of the surface upon which they worked, the cubists assayed an over-all unity of form and background which functioned somewhat in the manner of camouflage and was an unwitting forerunner of it.

By 1913 through the medium of *collage* (pasting into compositions newspaper cut-outs, pieces of wallpaper and other flat materials commonly found in the artist's environment) they approached even

more closely an integration of pictorial elements in terms consistent with the two dimensions of their picture plane, and with it painting at last, if paradoxically, took on a new dimension, a dimension in terms of the reality of the picture plane itself rather than of illusion.

Cézanne's idea of incorporating into the same picture suggestions of different viewpoints of different objects was a further unfolding in this direction; cubists, in evolving the circulating viewpoint, varied this idea by presenting *single* objects from different viewpoints. If Cézanne's table top was tilted the bowl on it was not, suggesting separate perspectives, whereas in cubism the bottle, for example, was presented as if viewed simultaneously from the top, bottom and sides, the several aspects arranged side by side as if the object had been flattened out. The method of analyzing objects through this technique, referred to as simultaneity or circulating viewpoint, was used by Picasso as early as 1909. Through the years it was increasingly employed in cubism, *collage*, and after 1914, in cubist synthesis, when the space division of Seurat and the tonic effect of Rousseau's self-taught art also became a spur to cubist evolution.

Active in cubism besides Picasso and Braque were Gris, whose somber color and equilibrium of obliques (4) contrast sharply with the robust and high-keyed mechanomorphic art of Leger (3); also the unpredictable and inimitable Duchamp; his gifted brother Villon, and Delaunay and Picabia, who were the first cubists to return to chromatic color; the eloquent La Fresnaye; Gleizes and Metzinger, who were theorists; and Marcoussis.

All cubist paintings are abstract representations of objects from nature; they are figurative art, as contrasted with nonfigurative. Other terms for figurative abstraction are: representational, biomorphic, organic. These may also be called near-abstractions.

Across the span of thirty years the generating force of cubism continues and has spread today to the ends of the earth. Many American painters working in Paris came under this influence quite early, and upon returning to America in the years immediately preceding World War I, they enthusiastically incorporated the new esthetic in their paintings. Apathy and hostility of the public, among other causes, diverted some of them later to less provocative styles. It was for the next generation of American painters to pick up the trail that had led out of cubism. However, the "Armory show"* and other pioneer activities here had a far-reaching influence in persuading the artist to persist and in preparing a public that would eventually support his advanced ideas.

Back on the European scene, we revert to futurism which, initiated with the publication of Marinetti's *Manifesto of Futurism* in 1909, was the most aggressive and, if short-lived, certainly the most polemic art movement of our time. Its revolutionary ideas were empiric rather than pedagogic and were filled with iconoclasm in its defiant repudiation of traditional art, supplanting idols of the past with the machine of the present. Deriving from neo-impressionism and cubism, its vibrant forms were articulated in complementary chromatics. In the *Technical Manifesto of Futurist Painting*, 1910, several novel theories were stated, each of which fit into the over-all scheme termed *dynamism*. Briefly, these were:

Dynamic or Kinetic Continuity: Painting of successive stages of an object in motion (7).

Lines of Force: A visual projection of force-lines to indicate speed, force and velocity.

Simultaneity: Aiming to project on the canvas objects and sensations of the artist's immediate environment together with those within the periphery of his experience, in order to bring into pictorial unity through this simultaneity of experience, their dynamic relations to each other in time and space. (This is a time-space concept and may be accepted as a theory never quite transmuted to futurist painting. Though various aspects of it were effectively used, it remains to a large extent unexploited and still offers great imaginative possibilities for the creative artist.)

Transposition of Artist (or Spectator) — another aspect of *simultaneity:* Synthetizing both what

* International Exhibition of Modern Art, 1913.

is seen and what is recalled, the artist no longer looks upon the picture as if from the outside but transfers his viewpoint to the core of the action within the painting itself. From this unique position, he participates in the pictorial dynamics of an expanding and volitant universe.

Interpenetration of Planes: Extending further the principle of *simultaneity* to include, for example, walls, the earth, nature, visualized by the artist as allowing optical penetration (7).

Adding to the already wide ramifications of their profuse and argumentative theories, futurists also made an attempt to suggest sensations of sound and even of smell as visual and pictorial elements.

After the war, the younger group in Italy carried on futurist principles, but they lacked the ebullience of their predecessors, the sculptor-painter and leader Boccioni, and the artists Balla, Carrà, Roussolo and Severini.

That twentieth-century pioneer American painters should have been drawn to many of the principles of futurism is not surprising. The machine and its multiple activity, speed, force, dynamics, are salt to the American spirit, and many of our serious painters generously flavored the character of their work with valid pictorial ideas from futurist sources. While futurism owes a debt to cubism, it reacted against cubism in many ways, especially against the deliberately restrained color of the analytical period. The monochromatic order of early cubism accentuated the structural and psychological organization of color in place of representational color association, and by 1913, when cubists returned to chromatic color, this rationale was implicit in their work. In the meantime in 1912 other painting movements stressing color — orphism (Delaunay) and synchromism (MacDonald-Wright) — had become active in France. At times geometric, while at others somewhat amorphous in character, these were the earliest nonfigurative works to make their appearance in twentieth-century painting. Nonfigurative art, also referred to as nonrepresentational or nonobjective art or pure abstraction, extends from the completely amorphous improvisations of Kandinsky to the pure geometry of Malevich.

It was in Russia that this latter absolute form of expression came into being. The architectonics of suprematist painting under the leadership of Malevich, 1913, and those of Rodchenko's nonobjectivism, 1914, both flourished in Moscow (8). Their concepts, founded on the square and the circle, formed the nucleus for new ideas in painting, typography, advertising and poster layout, both abroad and in America. In turn these movements, with Russian constructivism, which was launched under the guidance of Tatlin in 1913, produced two- and three-dimensional constructions, the principles of which were later to reverberate through American abstract painting. Also in Russia, in 1919, the nonfigurative painting style of proun was expounded by Lissitsky as a link between constructivist painting and modern architecture. Later Gabo and Pevsner joined the constructivist movement, and their experiments with plastics had a wide influence.

Most of these groups had large active memberships and their recurrent exhibits were well attended, especially in the first years after the revolution. The experimental theatre in Russia was responsive almost at once, and the new ideas changed its concepts of design, directing, acting and playwriting, affecting other countries as well. In 1920 the turning point came, and within a year abstract art was no longer officially sanctioned in Russia; the artists thereafter applied the theories they had experimentally developed to furniture and book design, posters and other utilitarian media. These movements, although abandoned in the country of their origin, provided a laboratory of ideas for the artists of other countries, especially Germany, France, England and America.

Mondrian, who was to adhere all his life unswervingly to an austere, self-imposed abstract esthetic, had begun to paint completely abstract pictures when he returned to Holland after the beginning of World War I. These followed a series of analytical cubist pictures painted in Paris from 1910 to 1914. Neo-plasticism, of which he was a leading exponent, was founded in Holland in 1917 by *de Stijl*, a group

headed by the artist-theorist Doesburg. This group provided great stimulus to pure abstract painting and particularly to international-style architecture. Its publication, *de Stijl*, pioneered in expounding advanced theories of art, architecture and design.

De Stijl's creative drive remained potent for years, and the Bauhaus, started in Weimar, Germany, in 1919, while influenced by Russian art, was also very much in debt to the precise principles set forth by *de Stijl*. Artists at the Bauhaus, working in all fields, drew analogies between the esthetic unity of a work of art and the esthetic necessity of design for use. A flood of inventive ideas for modern living — architecture, furniture, utensils, rugs, fabrics — began to flow from the Bauhaus, and within a decade "art in industry" became a watchword to progressive designers all over the world. In America, where advanced technology had long coped with the problems of designing objects for use in terms of their own inner necessity, the new ideas from abroad fell on fertile ground.

Mondrian carried on through life the original principles set forth for himself and incorporated in *de Stijl's* credo at the group's inception. These fundamental precepts in painting which he later brought to a logical conclusion may be briefly summarized as: the two-dimensional surface plane as the basic law of a new pictorial reality; horizontal and vertical direction as a basic law of the surface plane; and primary color as a basic color-law of paint. Mondrian wrote: "To create pure reality plastically, it is necessary to reduce natural form to *constant elements* of form and natural color to *primary color*." Mondrian has a wide circle of admirers in America, and although only a few painters have been influenced by physical aspects of his work, his pure searching spirit reflected in his painting and in his terse and logical writings, has been an inspiration to many abstract painters here. Beyond this, his compulsion toward perfection is of interest psychologically to surrealists.

A recapitulation of events shows that the flame of twentieth-century art never burned more brightly than during the year immediately preceding the first World War. In Paris cubism had reached its apex analytically and had already arrived at *collage*, which was to prove such a rich spiritual source for painters later. Orphism and synchromism had attained their moment of glory, brief but scintillating. Duchamp had already created highly inventive and fecund works growing out of an impersonal intrigue with chance and the esthetics of the machine, through which he and Picabia, working with similar detachment, profoundly affected the dada movement several years later. In Holland, Mondrian had begun his first "plus and minus" pure geometrical abstractions (9). In Russia Malevich, Tatlin, Rodchenko and others had done their definitive nonfigurative works, and in England, vorticism was in the foreground of attention. Under the banner of the progressive Blue Rider group in Germany, Klee in his early fantasies and Kandinsky at his explosive best contributed their measure. Chirico in Italy and France had already evoked the magic of his disquieting private world; Chagall was creating his hallucinatory folklore; while the fireworks of Italian futurism illumined the prewar milieu. In America the dawn was breaking. Many artists had returned from Europe and began to introduce the new concepts in their work. This tremendous creative activity burst forth in the white heat of an all-consuming fire, whose flames spread across the European continent, spanning the ocean to America.

It was now that the war interrupted the efflorescence of contemporary art. Dadaism, the first art movement to develop during the war, was born of disillusionment, frustration and defeatism, with its principal aim a categorical negation of existing esthetic, philosophical, social and moral values. The iconoclasm of the dadaists exceeded even that of the futurists, whose technique of propaganda was also used. But unlike the futurists, whose corypheus, Marinetti, was a proto-fascist, they were generally politically leftist.

The shock value of dada propaganda was psychological and its effectiveness lay in the ability to arouse a public from lethargy. Anarchism in art — wholesale, full-scale violation of esthetic precepts —

was their dogma, yet while holding in contempt all existing forms of art, they did not hesitate to utilize the technique of *papier collé* as well as compositional ideas from cubism and constructivism. Furthermore, like the futurists, they extolled the machine as an esthetic object. Despite dada's negative philosophy, it fed from sources well within the classic stream, and, interestingly enough, after eddying through its own many and devious passageways, emerged as the romantic tradition which ultimately led in the direction of surrealism.

When dada was founded in Zurich in 1916, its leanings were principally literary and its only artist was Arp (12). The following year Duchamp and Picabia (10, 11), both of whom had already done a number of proto-dada works, founded the dada group in New York with the American artist, Man Ray. In 1918 Berlin's group, the most active politically, was started and its members included Grosz and Heartfield. The same year Ernst and Baargeld formed the Cologne group and together with Arp, who later joined them, made some of the most original works to come out of dada. In 1919 another German group was formed in Hanover, where the born dadaist Schwitters made his *collages* from waste materials. Finally in 1920, the Parisian group was organized, and most of the artists from the various centers participated. Writers including Breton, Eluard and Tzara were particularly active and they were to continue uninterruptedly with the advent of surrealism. In the various countries dada exhibitions were held in great profusion, and their noisy and deliberately incongruous demonstrations are now legendary. It is significant that the first internationally organized art movement in the twentieth-century was dada, which, in the course of its program of destruction, also destroyed the limitations of national boundaries in the promulgation of art concepts.

With the appearance of its first manifesto by André Breton in 1924, surrealism was initiated and became and remains today the cardinal germinating source for many of the most gifted artists on the international scene. The surrealist point of view has always been present in the province of art, but in the twentieth-century the torch is in the hands of a considerable body of artists who have devoted themselves as a group to a passionate espousal of the surrealist spirit. They are in a constant process of defining its essential nature, which they proclaim to be fluid and everchanging. The surrealists originally formulated a concrete program and have ever since systematically developed it. Taking a "revolution in consciousness," their objective, to correspond first and foremost with psychological processes, they obtained the key from Freud for releasing material from that vast domain hitherto considered obscure and unfathomable, the realm of the unconscious. The surrealist work of art, a means of communicating psychological insights, has become a scientific mirror held up to nature and the contemporary world where we may see, even if we do not yet recognize, inner and secret processes which come into focus only fleetingly under the spotlight of commonplace reality.

Breton's *Second Manifesto* in 1930 reaffirmed the philosophic and scientific position of surrealism, and called upon its artists to seek only the highest and purest standards. It was Breton's belief that surrealism would spread to the four corners of the earth through its ability to reach "live youth," an opinion which is being rapidly substantiated. Artists are working and exhibitions have been given in world centers including (apart from Paris), Brussels, Hartford, New York, Berlin, Basle, London, Zurich, Barcelona, Copenhagen, Prague, Belgrade, Tenerife, Tokio and Mexico City. The leading surrealist painters include Miro,* Ernst, Masson, Tanguy, Man Ray, Magritte, Matta, Seligmann, Oelze, Delvaux, Dominguez, Brauner, and, formerly, Dali. Admired by the surrealists and presented in their exhibitions because of their great inspiration to the movement are Picasso, Chirico, Duchamp and Klee. Kandinsky and Chagall were also proto-surrealists.

Having the real and beyond-the-real in which to move, the surrealist may chart any direction.

* Although Miro has remained independent, he is credited with being a leading surrealist.

The choice, Hugnet writes, is his own, and "this individuality of choice is as personal and distinctive in each painter as the selection of words and reappearance of certain images is to each poet."

Because subjective processes are involved, surrealist works are generally thought of as retaining elements of representation, but just as in abstract art, there are many nonfigurative paintings in surrealism. The surrealist covers a range from the abstract reliefs of Arp to the *trompe-l'oeil* of Dali's "instantaneous and hand-done color photography of the superfine, extravagant, extra-pictorial, unexplored . . . images of concrete irrationality."

The surrealist state of mind, then, is neither static nor fixed, and its various techniques lead to high creativity. Creative release is regarded not as the exclusive property of the few but is held to be within reach of everyone. Images derive anywhere from conscious to unconscious states; sources of method from automatism to chance.

Many avenues of surrealist approach have been discovered. Depending upon the immediate drive, the surrealist painter may hit upon one of the following paths and techniques, or invent his own, in arriving at a resolution:

Psychic Automatism: A process in which unpremeditated uncensored imagery is released pictorially. Automatism is a fundamental of surrealist procedure, and has engaged the talents of the majority of surrealist artists at one time or another (64, 86, 93, 99).

Chance: Accidental configuration or "decalcomania of chance," a method which in the words of Breton "puts within everyone's reach the making of poetry" (69, 87, 94). Chance results are often assisted and developed, and through free association may suggest successive images. Images of surrealism also accrue from *collage, frottage* (rubbings), *fumage* (flame smoke) or any other fortuitous method consciously or unconsciously arrived at. Dada examples "arranged according to the laws of chance" were the result of more volitional means (10, 12).

Double Imagery: Rediscovery of the double image in "paranoiac phenomena"* (74, 98).

Dream Symbolism: Exploration and recording of unconscious symbols from the world of the dream under the impulse of Freud's scientific findings (15, 16).

Fantasy: Poetic and revelatory recordings from the realm of the marvelous, the unbridled imagination and the subliminal mind (59, 61, 100).

Hallucination: Compulsive materialization of "hypnagogical visions," irrational illusions, delusions, obsessions and hallucinatory fantasy (79, 82, 92).

Metaphysical Experience: Evocation of other-world imagery, aloof and abstract. Dream atmosphere pervaded by intangibly fixed laws of time and space. "Planetary melancholy" (13, 81, 97).

Dwelling upon the marvelous, the irrational and the delirious, the surrealist investigates the dream, the myth, the metaphor and the fable. Introducing elements of shock and surprise, he sensitizes his audience and prods it to a new consciousness through the vivid experience of convincing phenomena.

Throughout twentieth-century painting there is a changing and expanding concept of the meaning of reality and a corresponding attempt to create a language of symbols and images by which to express it — a modern iconography. These concepts pass through many phases until they include almost everything within the scope of human experience. They are projected without concession to familiarity as a record faithful to the passionate inspiration that released them. It is as if after being imprisoned in realism, through the imaginative faculties of fresh vision they had suddenly escaped into new dimensions.

The eye is no longer limited to a fixed focus, but supplements it with movement. As the focus moves, the point of view is augmented and becomes more penetrating, and even the canvas is submitted to newly comprehended exigencies. The artist is now truly the maker of a new world, the picture, and he makes

* Cf. Dali's text, page 140.

it in the image of things he thinks and feels about the world and about himself, not as an imitation of nature.

Realities in painting as differentiated from those in nature are progressively defined. The reality of the object is broken down in order to penetrate other aspects of its nature and identity — its meanings and implications. Its physical aspect is altered from this new point of view. Its relation to environment is emphasized and these relationships become part of the picture. Intangibles are given visual identity.

Not only does the focus move about the object, but the object itself is set in motion, progressively in space, kinetic and stroboscopic. Flux or physical movement takes place within plastic movement. The relationships between object and environment are now more pronouncedly in accord with physical laws, dynamic tensions. Elements of time and space that enter through movement alter concepts of form. The visualization of abstract concepts causes a further transition, and representation vanishes to the point where it is completely discarded. Next, the plastic elements of the picture come into view, and in turn the basic laws of the canvas are isolated. As far as it is possible to go in a given direction, the creative process and laws of nature externally observed merge into a new reality, the autonomous domain of the canvas.

In the meantime, what has happened to the human form? A process of conversion takes place here, too. The human form is changed into an image or idol, primitive, deified on the altar of a new orientation, science. The idol, as a detached entity, is examined, broken up into surface planes and structure. Analysis of the human form is in terms of geometry and drama — the clinical drama of the dissecting room.

With emphasis on other realities, the outlines of the human form become absorbed into the environment, and commonplace representation is reduced to a minimum. Neither the human form nor the idol now exists. In their place is an object which can be dissembled and the parts used to create another object — the picture, one that functions with the precision of a machine. This is not a mechanical process but a poetic one, requiring imagination and invention. Presently man is converted into a machine, then a halo is cast about the machine; eventually it is dissembled and the parts reassembled to represent the human form.

At about this point in the reversal there is a sudden rejection of values expressed within the orientation of new points of view. Intended to be destructive, this rejection paradoxically carries the seeds for the next powerful dynamic tangent: turning the searchlight inward to examine subjective or inner processes. The method is still scientific. The analysis this time is psychological. As if by magic whole new worlds of the spirit are lit up, worlds of poetic inference, mythological worlds, worlds of haunting reminiscence, of unearthly fantasy and of disquieting dreams.

New realities are symbolized which transcend commonplace representation: the secret life of the object; the dynamics of an expanding universe; the unseen mechanisms of nature; pictorial law; the all-but-inscrutable phenomena of the mind and the emotions; light and form, essence and sensibility, and all the marginal experiences that tell of wonders still to be explored.

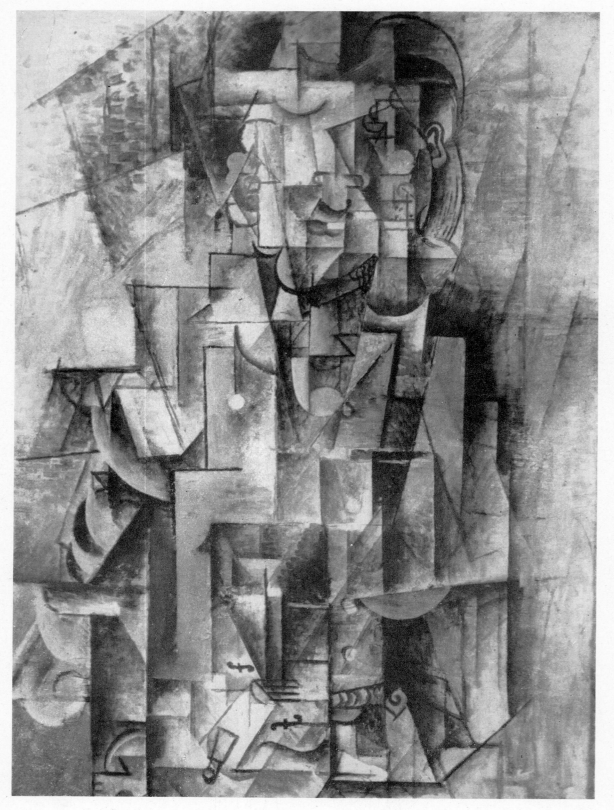

1

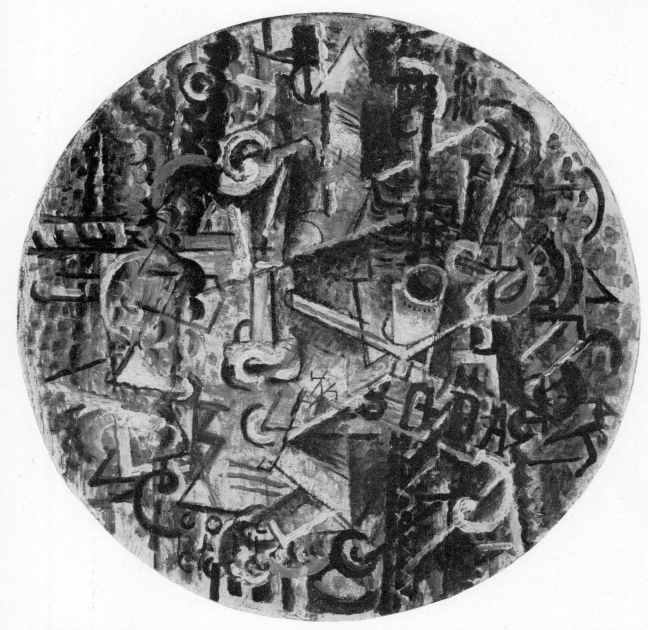

2 GEORGES BRAQUE
SODA, 1911, oil 14⅛″ in diameter.
Collection Museum of Modern Art.
Born Argenteuil, France, 1882. Lives in
Paris.

1 PABLO PICASSO
LE MANDOLINISTE, 1910, oil
39 x 28″. *Collection Mr. & Mrs. Walter
C. Arensberg.* Born Malaga, Spain,
1881. Lives in Paris.

— In the early days of cubism, Picasso and I were engaged in what we felt was
a search for the anonymous personality. We were inclined to efface our own
personalities in order to find originality. — Georges Braque from "Testimony
against Gertrude Stein," *Transition*, 1934-35.

— From the painters of the origins, the primitives, whose work is obviously
different from nature, down to those artists who, like David, Ingres and even
Bouguereau, believed in painting nature as it is, art has always been art and
not nature. And from the point of view of art there are no concrete or abstract
forms, but only forms which are more or less convincing lies. That those lies
are necessary to our mental selves is beyond any doubt, as it is through them
that we form our esthetic point of view of life. — Statement by Picasso to de
Zayas, 1923.

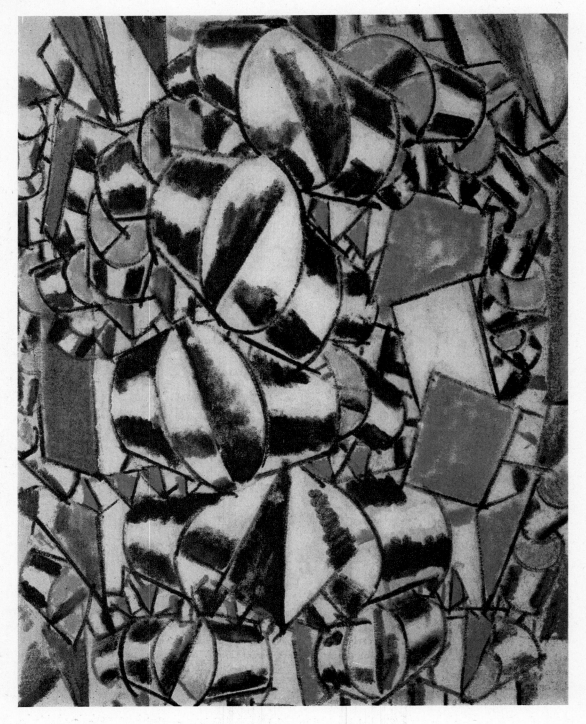

3 FERNAND LEGER
CONTRASTE DE FORMES, 1914,
oil 51 x 38″. *Collection Mr. & Mrs.*
Walter C. Arensberg. Born Argentan,
France, 1881. To U. S. 1940. Lives in
New York.

— The mechanical object even if it is not completely beautiful can serve as well as a landscape or figure as first material for a plastic work. It is a matter of choice in the beginning; wishing to obtain brilliancy and intensity I should prefer this material to any other. — Fernand Leger, "The Esthetics of the Machine," *Little Review*, 1923-24.

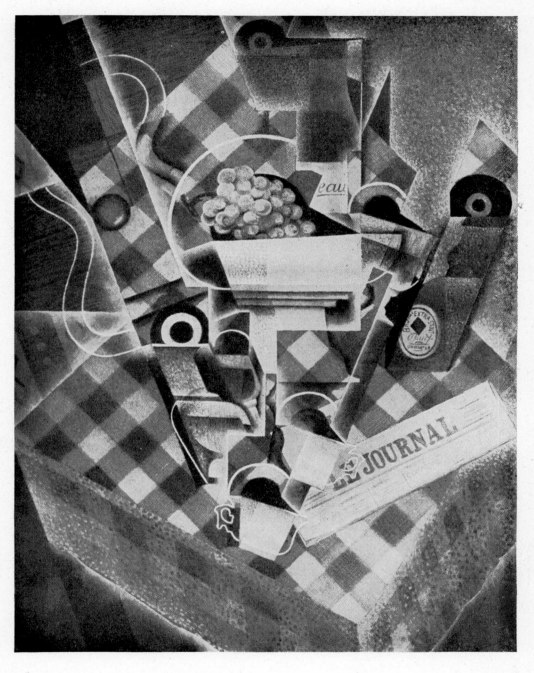

4 JUAN GRIS
STILL LIFE, 1914, oil. Born Madrid, 1887. Lived in Paris. Died 1927.

— I work with the elements of the mind; with imagination, I try to make the abstract concrete, I go from the general to the particular, which means that I start from an abstract to reach a reality. My art is an art of synthesis, a deductive art. — Juan Gris.

— What really counts is to strip the soul naked. Painting or poetry is made as one makes love — a total embrace, prudence thrown to the winds, nothing held back. — Joan Miro, from "Où allez-vous Miro?" by Georges Duthuit, *Cahier d'Art*, 8-10, 1936.

6 JOAN MIRO
THE HARLEQUIN'S CARNIVAL, 1924-25, oil 26 x 36⅝".
Collection Albright Art Gallery, Buffalo. Born near Barcelona, Spain, 1893. Lives in Palma, Majorca.

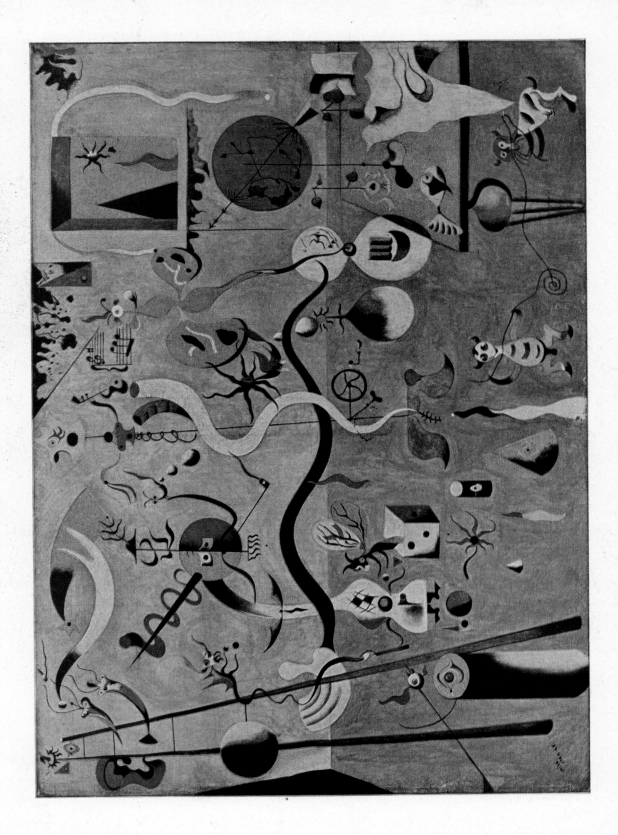

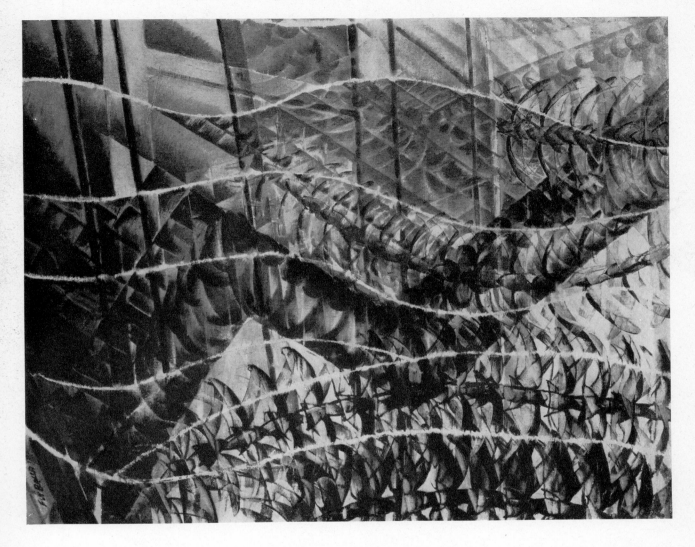

7 GIACOMO BALLA
PROGRESSIVE LINES + DY-
NAMIC SEQUENCES (THE
SWIFTS), 1913, oil 38 x 47″. *Col-
lection the Artist.* Born Turin, Italy,
1871. Lives in Rome.

— We firmly believe that only by means of motion does the object enact its
drama and establish the conditions for artistic creation. — *Technical Manifesto
of Futurist Painting*, 1910, signed by Boccioni, Balla, Carrà, Russolo and Severini.

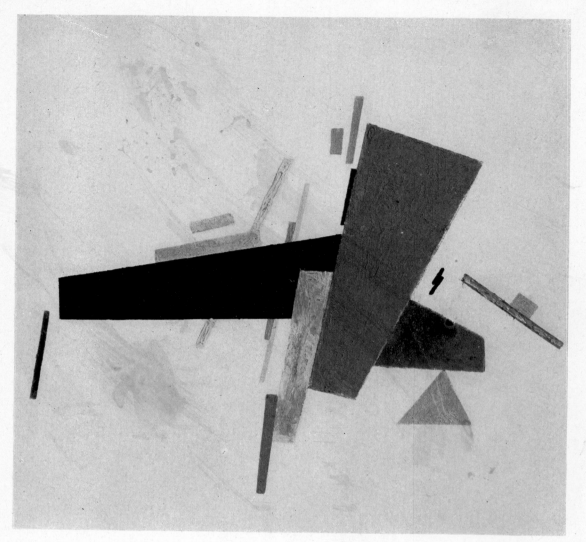

8 KASIMIR MALEVICH
SUPREMATIST COMPOSITION, c. 1915,
oil 21 x 21". *Collection Art of This Century.* Born
Kiev, Russia, 1878. Lived in Leningrad. Died 1935.

—Fine art is banished. The artist-idol is a preju-
dice of the past. Suprematism presses the whole of
painting into a black square on a white canvas. . . .
—Kasimir Malevich, from *Die Kunstismen, Zurich,*
1925.

9 PIET MONDRIAN
COMPOSITION, 1915, oil 34 x 42". *Collection
Kröller-Müller Foundation, The Netherlands.* Born
Amersfoort, Holland, 1872. Lived in Paris and
New York. Died 1944.

—By the horizontal vertical division of the rec-
tangle, the neoplastic artist obtains tranquility, the
balance of duality: individual and universal.—
Piet Mondrian.

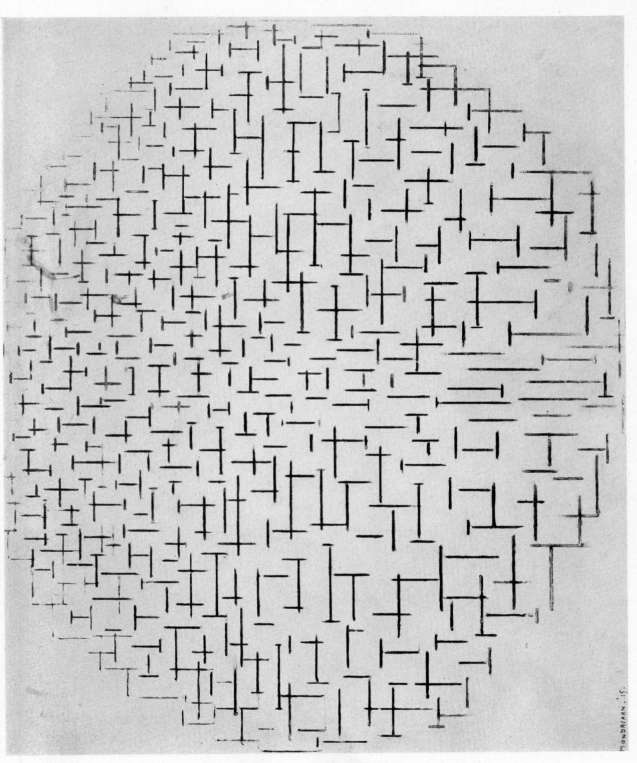

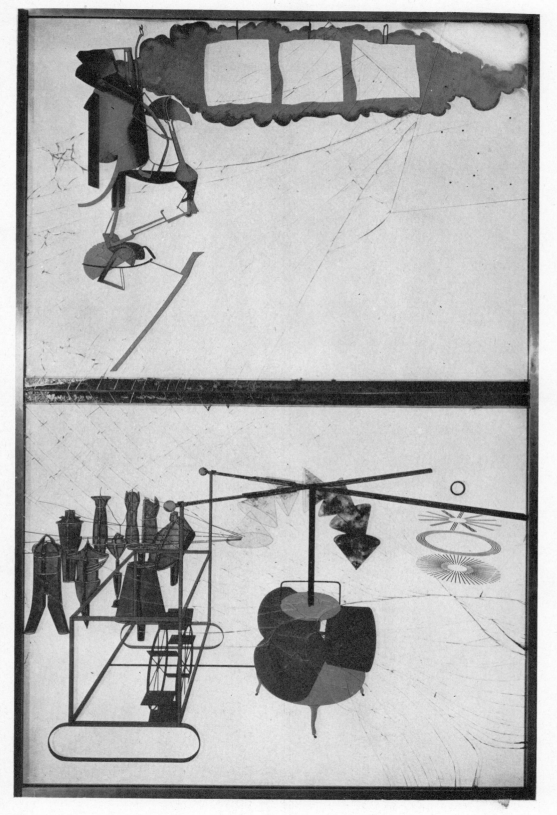

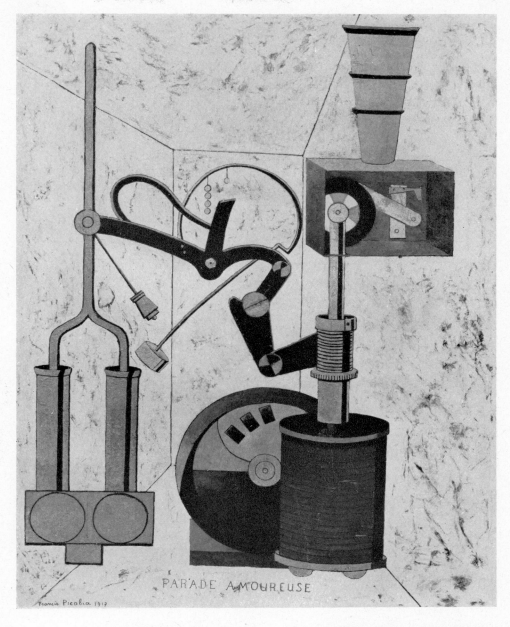

PARADE AMOUREUSE

Francis Picabia 1917

11 FRANCIS PICABIA
AMOROUS PROCESSION, 1917, oil 34 x 29". *Collection Mme. Simone Kahn,* Paris. Born Paris, 1878. Lives in Paris.

— *Le Salon d'Automne* will open in a few days. May I offer a word of advice to the members of the jury: to refuse pitilessly all that they like and accept only that which horrifies them; in this way we should perhaps have an exhibition less stupid and less monotonous. . . . — Francis Picabia, from *The Little Review,* 1922.

10 MARCEL DUCHAMP
THE BRIDE STRIPPED BARE BY HER OWN BACHELORS, 1915-23, oil on glass 110 x 69". *Collection Miss Katherine Dreier.* Born Blainville (Seine-Inférieure), France, 1887. To U. S. 1942. Lives in New York.

— Basically the Bride is a motor. But more than being a motor transmitting its timid-power, she is the timid-power itself. This timid-power is a sort of essolene, essence of love. When distributed to the virtue-frailty cylinders, and within range of the sparks from her constant life, it causes the expansion of this virgin, now come to the state of her desire. . . . — Marcel Duchamp, fragment translated by J. L. From *Surrealism* by Julien Levy, 1936.

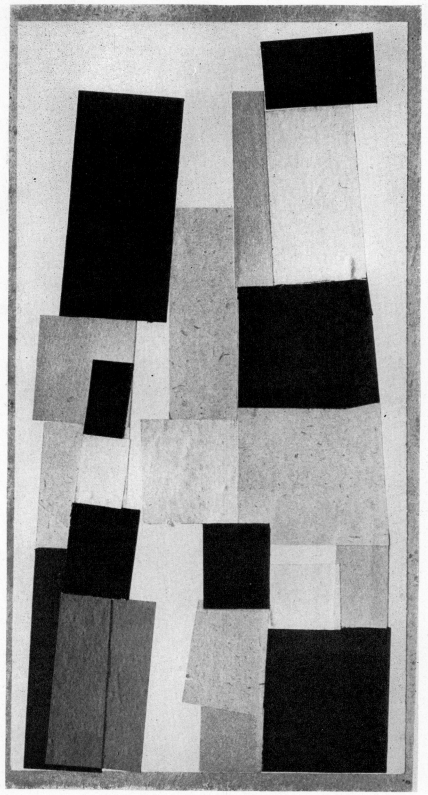

12 HANS ARP
COLLAGE WITH SQUARES
ARRANGED ACCORDING TO
THE LAWS OF CHANCE, 1916.
Collection the Artist. Born Strassburg,
Germany, 1887. Lives near Paris.

— Dadaism carries affirmation and
negation to a point of nonsense. In
order to reach indifference, dadaism is
destructive. — Hans Arp, from *Die
Kunstismen*, 1925.

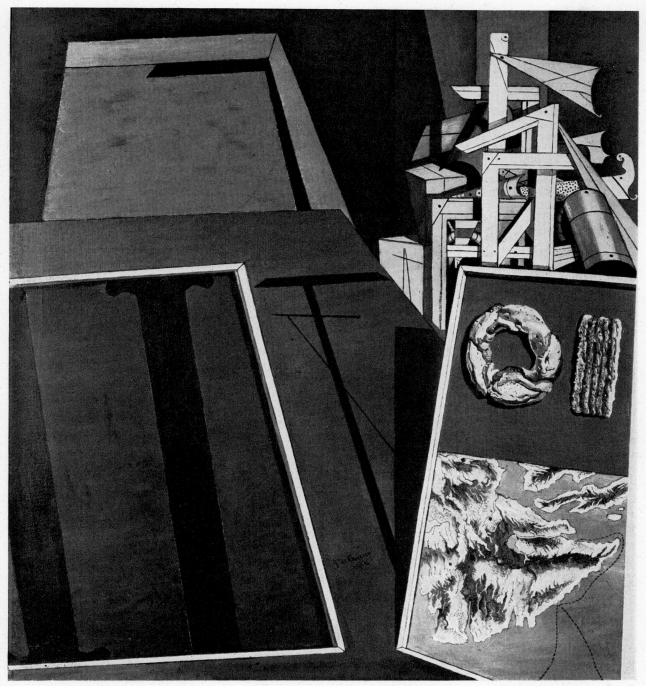

13 GIORGIO DE CHIRICO
EVANGELICAL STILL LIFE,
1916, oil 31 x 28″. *Private Collection.*
Born Volo, Greece, 1888. Lives in
Italy.

— Above all it is necessary to rid art of everything it contains known to us up
to now, every subject every idea every thought every symbol must be put aside.
Thought must necessarily detach itself from everything, from logic and sense;
it must keep away from all human obstacles to such a degree that things appear
under a new aspect as if they were illumined by a constellation appearing for
the first time. — G. de Chirico from "Thoughts on Art," *Les Peintres Francais
Nouveaux,* 29, 1927.

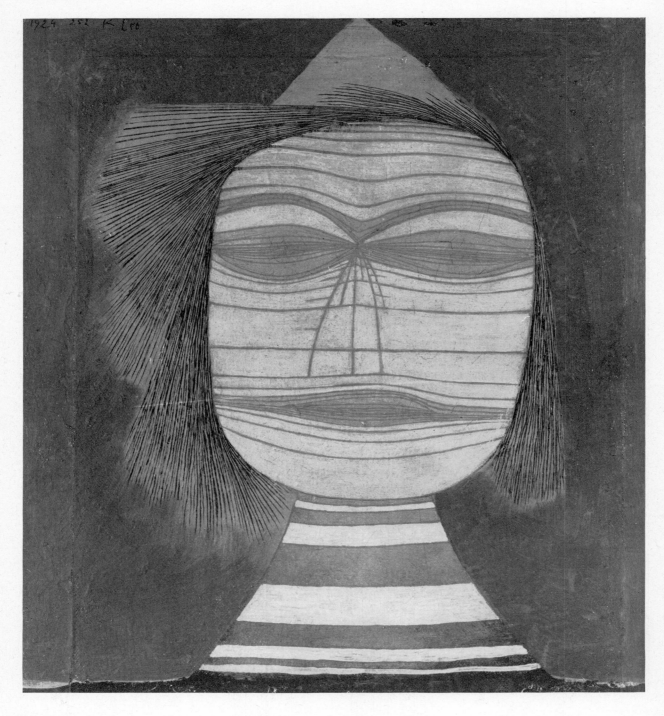

14 PAUL KLEE
ACTOR'S MASK, 1924, oil 14 x 12½". *Private Collection.* Born near Berne, 1879. Lived in Germany and Switzerland. Died 1940.

— The heart must do its work undisturbed by reflected consciousness. To know when to stop is of the same importance as to know when to begin. — Paul Klee, from *Paul Klee* by Karl Nierendorf, 1941.

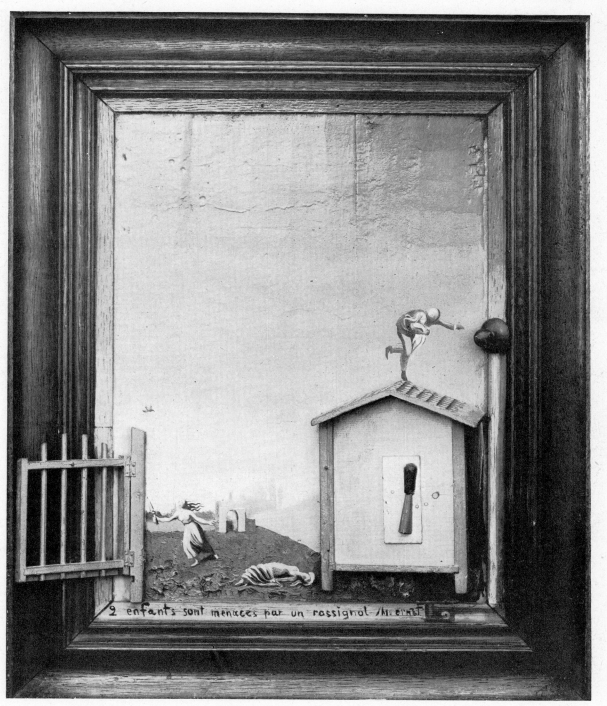

2 enfants sont menacés par un rossignol /M. ernst

15 MAX ERNST
TWO CHILDREN ARE MEN-
ACED BY A NIGHTINGALE,
1924, oil and wood construction 18 x
13½". *Collection Museum of Modern
Art.* Born Bruhl, Germany, 1891. To
U. S. 1941. Lives in New York.

— Thanks to studying enthusiastically the mechanism of inspiration, the sur-
realists have succeeded in discovering certain essential poetic processes whereby
the plastic work's elaboration can be freed from the sway of the so-called
conscious faculties. — Max Ernst, *Inspiration to Order*, 1932.

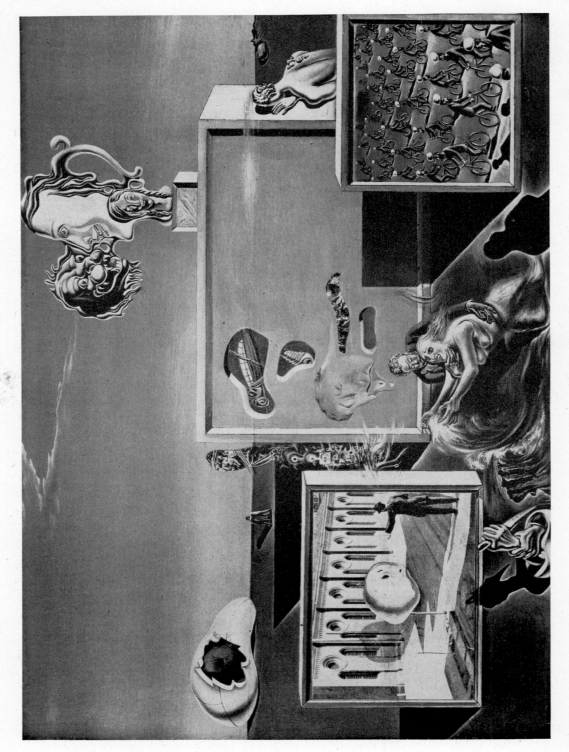

16 SALVADOR DALI
ILLUMINED PLEASURES, 1929, oil 9 x 13¼". *Private Collection*. Born Figueras, Catalonia, 1904. To U. S. 1938. Lives in Del Monte, California.

— My whole ambition in the pictorial domain is to materialize the images of concrete irrationality with the most imperialist fury of precision, in order that the world of the imagination and of concrete irrationality may be as objectively evident, of the same consistency, of the same durability, of the same persuasive, cognoscitive and communicable thickness as that of the exterior world of phenomenal reality. — Salvador Dali, *Conquest of the Irrational*. 1935.

2 AMERICAN PIONEERS IN TWENTIETH-CENTURY PAINTING

THE APPRECIATION of progressive ideas in painting is of basic importance to the morale of the vanguard artist. If the atmosphere in which he works stimulates and encourages him, he is fortified against the conservative faction automatically present when artists commit themselves to the advance guard. The stage is thus set for controversy, and the painter has both the sympathy of an understanding audience, whether large or small, and the opportunity for sharpening his perceptions against the opposition.

In Paris, the indignation of both critic and public raged furiously during the last quarter of the nineteenth-century. Through the years the struggle between conservatives or *Salon* painters and the innovators — the impressionists, post and neo-impressionists — continued unabated.

On one side revolutionary painters were dedicated to formative concepts that in retrospect are seen to have been of far-reaching significance. Intensely felt and articulated, these new, revitalizing elements in art were defended by a few of the leading intellectuals of the day and by a few commercial galleries (Goupil, Durand-Ruel and Vollard) which had on their staffs men of the necessary conviction and courage to offer to an unprepared public wares that involved it emotionally on sight. In the civic domain the *Salon des Refusés* had been organized during an impasse back in 1863 as a liaison between the painter of living art and the public. In 1884 the *Société des Indépendents* took over this function.

The opposition comprised a considerable body of conservative writers, an even larger aggregate of *Salon* painters, and beyond that the general public. Although staggeringly outnumbered, the advanced group made up in determination and tenacity what it lacked in size. If recognition did not come to these artists until much later, the best are today accredited masters and theirs is the final victory. In the early years of the twentieth-century, though the cubists and *fauves* had their battles too, the precedent set by their older compatriots made the path a little less hazardous. Since art continued to develop, it followed that these twentieth-century advanced groups were still further removed from nineteenth-century *Salon* academism. Even so their paths, though far from smooth, were not beset by the obstacles that had obstructed the way for earlier painters.

After the turn of the century, Paris, with its tremendous art activity acting as a magnet, naturally attracted increasing numbers of the more adventurous among American artists. In the years immediately preceding World War I, when these painters began returning to America, they clarified and developed here the wealth of new ideas with which they had made contact abroad. The spiritual level of this phase yielded results that remain impressive achievements in twentieth-century art in America. As a whole the best work of the pioneers belongs to this period when the urge was most intensive — from 1914 until just after America's entrance into the war. This repeated on a smaller scale the pattern of events abroad just preceding the declaration of war. It is not without interest that of some two dozen artists who assiduously pursued the new course, only a few continued consistently in their appointed direction, while others who also distinguished themselves as pioneers reverted only intermittently to abstract facets;

and several were to turn about completely as though their inspiration, far from its source, had dwindled. Nevertheless this interval was important, especially since it established in our midst a coterie of painters whose ideas eventuated in our present nationwide interest in abstract and surrealist concepts. And during this period, though there was much opposition, support also sprang up, fervid and staunch enough to protect the flame when any gust of wind might have blown it out. Economic factors and antipathy on the part of the public, as implicit as they were in the situation, were still not potent enough to assert themselves at this stage as a determining factor in the survival of the new art.

So it seems evident that here as abroad entrance into the war was the decisive factor in breaking off the thread of development. After the war increasing antipathy and the concomitant difficulty of earning a livelihood from abstract art diverted artists whose wavering confidence in the value and necessity of the new points of view caused them to temper their expressive means to conform with lagging understanding. It became the task of the younger generation to pick up the thread and carry on in spite of the pressure created by lack of moral and economic support.

In the very earliest days the rallying ground for twentieth-century painting was of course gallery *291* in New York, the only place in America to which the vanguard could turn. To the credit of its pioneering director, Alfred Stieglitz, is a long and formidable list of one-man exhibits by European artists such as Cézanne, Rousseau, Picasso, Matisse and others, as well as many of the significant American pioneers, among them Marin, Maurer, Carles, Dove, Weber, Hartley. The importance of the Stieglitz contribution in awakening public interest and his value as an educator in the best sense, through vision and spirit, are now historic. And there is little question also that *291* whetted the curiosity of the public and prepared the way for the *succès de scandale* which, standing alone above all other events in contemporary American art, was to follow several years later.

This was, to be sure, the "Armory show" of 1913. Attracting an estimated attendance of over one quarter of a million in New York, Chicago and Boston, 1090 works by three hundred artists were exhibited. Much has been written about the impact of this event upon the imagination of both artist and public, and its permanent effect on American culture. The section devoted to controversial art was relatively small but consistently brilliant and inspiring. All save a very few of the twentieth-century School of Paris painters, now famous, were represented, some with several examples. Of special significance was the inclusion of the finest examples of cubist painting, which, to the added glory of the show, were then contemporaneous. Important nineteenth-century French painters from Ingres to Henri Rousseau were also exhibited. Out of some two hundred American artists only a handful were of the advanced school, since less than a dozen painters were yet dedicated to the new esthetic.

Organized by the painter and connoisseur, Arthur B. Davies, and ably assisted by Walt Kuhn and Walter Pach, this event, privately subsidized, took many months of preparation both here and abroad. The show opened quietly enough, the ominous quiet before the storm whose fury is art lore of the most entertaining and salutary nature. That most people felt violently challenged did not deter others with more vision from becoming protagonists and substantiating their opinions by the purchase of works of art. Many of our pioneer collections of twentieth-century art date back to the "Armory show," the Eddy, Davies, Quinn, Arensberg and Bliss collections among others. The exhibit provided a good show and gained adherents, but moreover kindled among younger artists a desire to venture into untried fields. The endless discussions and exchanges of ideas sharpened their perceptions and stimulated their creative faculties. The book *Cubists and Post Impressionism*, by Arthur Jerome Eddy, was published one year later, the first book in English to deal with cubism. Earlier, abroad, the Americans Gertrude Stein, Leo Stein, Mr. and Mrs. Michael Stein and Etta Cone and Dr. Claribel Cone had begun to acquire works of the trailblazers.

Following the "Armory show," other exhibitions and galleries contributed to the crusading spirit. During the war the Montross and Daniel Galleries and later the Bourgeois had opened their doors to rebel painters, and *291* continued its lively series of one-man shows with increasing accent on the youthful American pioneers. In 1916 de Zayas opened his Modern Gallery and traversed the path blazed by Stieglitz. In the same year Willard Huntington Wright, (later famous as S. S. Van Dine), who had previously written articles and a book on modern art, assembled the Forum Show of American painters "to counteract prevailing prejudice against modern painting." Of the sixteen artists exhibited, five included nonfigurative paintings: Dove, Dasburg, Hartley, MacDonald-Wright and Russell.

Through the years writers for the press and art journals had been fiercely opposed to the new face of art. The exceptions are so few that they are worth noting. Contemporary with *291*, James Huneker was the lone figure unhesitatingly to accept twentieth-century art, covering with favorable comment exhibits by artists such as Matisse in 1908 and Picasso in 1911. His activities began easing off about the time of the "Armory show" at a moment when the star of another critic was in the ascendency. Henry McBride joined the New York Sun in 1912 and ever since has championed adventurous artists. McBride became their protagonist in the press and, himself a pioneer, led them through the storm and stress of the early years when they were struggling for the right to live. His ten years on *The Dial*, three on *Creative Art*, and thirty-one on the *Sun* constitute a record of keen insight. McBride's only senior in service is Cortissoz of the *Herald Tribune*, who unfortunately has been consistently in the opposing camp.

In 1915 Duchamp, whose *Nude Descending a Staircase* was the *pièce de résistance* of the "Armory show," came to our shores, followed by Picabia and Gleizes. Men of authoritative talent and established reputation, their presence and their ideas, especially those of Duchamp, which are filled with rich potentialities, stimulated effort in the direction of esthetic revaluations. Coinciding with other determining factors, the active period of the pioneers took place while these men were in our midst. Duchamp and Picabia, joined by Man Ray, had formed the first advance-guard group in America, dada. At the same time in 1917, Duchamp published the reviews *R-rong-r-ong* and *Blind Man*, while later, Picabia published *391* which continued abroad. These reviews, together with Stieglitz' *291* started in 1915, and his *Camera Work* and *Photo-Secession*, both founded several years before, were the first of the many "little magazines" to appear in America. The longest-lived (1916-26) and perhaps the most consistently advanced was the *Little Review*, which eventually devoted many entire issues to gifted young artists. These publications, reproducing the work of leading European and American painters with accompanying critiques, were extremely useful in nurturing a growing awareness, and in recording the progress of an evolving culture.

Organization in New York in 1917 of the Society of Independent Artists was another indication of the need for an open forum. Modeled after the *Société des Indépendents*, its platform was freedom from censorship and its slogan, "No jury, no prizes." It remains after twenty-eight consecutive annuals in New York a haven for the unknown and unsung. From the start famous names were democratically placed in alphabetical order by the side of obscure painters. This policy still holds, although Europeans have long since discontinued submitting their work. From the standpoint of esthetic interest, no show was ever to equal the first, which had been assembled before our entrance into World War I.

While the dominant sphere of influence for pioneer American artists during the first two decades of the century was unquestionably cubism, the effect of futurism was marked, for its central theme, dynamism, proved readily adaptable to this body of artists, who built upon it, some of them intuitively.

In this period American artists such as Stella, Feininger, Demuth and Sheeler introduced devices related to futurism, although in their use each painter had an individual purpose. Still we have but to consider that Stella in New York, Feininger who lived in Germany, Demuth in Lancaster and Sheeler in Bucks County employed variations of these devices again and again to realize that they came upon the

futurist ideas sufficiently independently of each other to indicate a larger common impulse.

Stella, an Italian by birth, assayed from 1914 a series of vibrant experiments that led to his Brooklyn Bridge pictures, culminating in the masterful *Brooklyn Bridge* (17). The suspended structure of the bridge furnished an admirable subject for the demonstration of the principles of *simultaneity*. Vibration and movement are established by a dense and dynamic interaction of lines of force within a personally conceived milieu of pulsating lights and shadows in which the complicated theme of expanding and converging obliques plays in all directions.

Feininger's long association with the Bauhaus and close friendship with Klee and Kandinsky did not cause him to invoke their spirits. Basic cubism and an apparently American predilection for futurist overtones became the tools of his art. *Zirchow-7* (18) is the last of a series of seven paintings of a church in that town in which each became progressively more abstract. In this final version the outward aspect of the church is now merely a memory and asserts itself only through the inner dynamics of its structure. By means of the interpenetration of planes and projection of lines of force, that which is understood becomes clearer than that which is observed.

In Sheeler's *Barn Abstraction* (19) the schematized arrangement of planes evolves from cubism, whereas in his *Pertaining to Yachts and Yachting*, movement is expressed through the grouping of sails which suggest a progression, a subtle diversion to his own purpose of the futurist device of kinetics.

Demuth's *Red Chimneys* (20) suggests the interchange of planes and extension of force lines. This is more directly expressed in others of his pictures where lines cleanly break the light as they cut across the composition and transform into a variegated pattern the handsome facades of buildings.

Apparently for reasons that relate to the engineering, architectural, mechanistic crosscurrents that course through our background, futurist method runs like a native strain through the work of these and other painters.

But light, also of an indigenous cast, communicates the reminiscence of American experience as well. The light in the atmosphere of the Eastern States, so admirably recorded by Winslow Homer and other traditional American painters, is in general sharp, intense, harsh. Striking upon pictorial structure and dynamics of cubist and futurist derivation, it imparts to the paintings a puritanical quality that may be termed "Yankee" — the illumined geometry of the American scene.

The breaking of light in Marin's masterful watercolors continues for three decades the characteristic fragmentation derived from cubism. However, although full of tight tensions and angularity, his pictures are expressionist, not the lush expressionism of Europe, but a New England variety, shaking with the agitated rhythms of splintering ice. In *Tree, Sea, Maine* (21), the electric emanations from the skies set up intense vibrations giving the area a cold luminosity like that of the aurora borealis.

It was color and not light or any of the other plastic elements that was the premise on which MacDonald-Wright and Morgan Russell founded synchromism in 1913. These two were the only Americans to launch an art movement abroad, and theirs was a reaction against the monochromatic pallor of cubism, arising independently but simultaneously with the parallel movement of orphism introduced by Delaunay. Synchromism's aim was to purify painting with color, and its products were abstractions that ran the gamut of brilliant hues. Its originators were convinced that pure colors alone, if scientifically inter-related, would supplant line, light, form and space. In short they strove to attain that elusive quotient, the essence of art, "through the means," to quote Willard Huntington Wright, "alone inherent in that art very much as music expresses itself in means of circumscribed sound." In *Synchromy in Blue and Orange* (22), 1916, painted here after MacDonald-Wright's return from abroad, the fusion of color is so subtle that it gives the work the appearance of some of his nonfigurative abstractions. On the other hand, in the photographic reproduction, the representational values reassert themselves, disclosing the identity

of the original subject matter, for the three figures, kneeling, seated and standing — the latter holding a child — are readily discernible.

Weber spent only a few years with abstractions, but during that interval investigated the phases of the Negroid period, analytical cubism, cubist synthesis, as well as futurism. Some of these sources are suggested in *Chinese Restaurant* (23), where the figures are disintegrated into fragments which shift and clatter. The central stroboscopic movement and the large static planes of the periphery set up oppositions, capturing excitement and visualizing action, noise and confusion.

Some of the pioneers pursued other directions. Alfred Maurer's *Abstract Still Life with Doily* (24) emerges from *collage*. The doily, though stencilled, has such verity that it seems actually pasted. Previously Maurer had been inspired by fauvism, successfully adapting its color-motifs to his landscape painting. The early Carles was also full of intense *fauve* coloring and this was placed at the service of an explosive style similar to Kandinsky's. Later, Carles (26), without limiting his freedom, became increasingly aware of formulated structure and in this he is allied to the late cubism of Picasso. Superimposing one upon the other, he obtains a freedom with measured control — a merging of the romantic and classic. O'Keeffe has been an independent worker from the start. Her immaculate surfaces and precision of form are nevertheless contemporary in character. The rectilinear arrangement and distribution of spaces in *White Barn, Canada* (25) are reminiscent of neo-plasticism.

Walkowitz's *Creation* (27), nonfigurative, is part of a series started in 1914 and akin to the sensibility pictures of Kandinsky done in the same period. However, Walkowitz later resumed representation, returning only intermittently to the more abstract manner.

The literary idea as basis for a picture was intrinsic in dada psychology. Man Ray's dada picture, *Admiration of the Orchestrelle for the Cinematograph* (28), is a travesty played by symbols of sight and sound. Auditory association lies in the gramophone horns, optical association in the ovals of light, and from these aural and visual tensions respectively emerge. Like a voice from a loudspeaker the words "Abandon of the Safety Valve" literally raise the platform with which the artist hopes to stir his audience. With almost machine-like precision, a playful, apparently nonsensical machine for seeing and hearing is constructed, a machine that in its plea for keener sensibilities, casually makes sense.

Among other vanguard painters during the century's 'teen age were Bluemner, Preston Dickinson, Ben Benn, McFee, Morris Kantor, Baylinson, Konrad Cramer.

The aggregate pioneer effort demonstrates that a variety of ideas had taken root but that most of them had been dislocated by our entrance into the war and by the subsequent undermining of cultural values. But there was still not enough natural confidence in our own powers of originality to forge through the difficult times ahead, perhaps because remnants of an old though unwarranted sense of inferiority still existed. The cultural continuity, very tenuous at this point, was held intact by the slenderest number of rising young artists who saw it through the lean years.

In evidence at all times was the propaganda of adverse critics and conservative artists who, terming twentieth-century art "the cult of the ugly," perennially pronounced it dead, and repeated the plea for what they called "sanity in art." This opposition took its toll after the close of the war and contributed to the temporary decline of abstract art; for despite the cumulative effort of its protagonists, the lay public, reluctant to forego the comforts of easy familiarity, knew what it liked, and that wasn't abstract art.

The pioneers, then, had made an excellent start with the new esthetic. They had also demonstrated in their work the maturity, dignity and contemporaneity of vision necessary in this demanding age. Though insecure in their ultimate evaluation of the importance of their cultural revisions, they nevertheless straddled the gap between European trailblazers and our own younger generation.

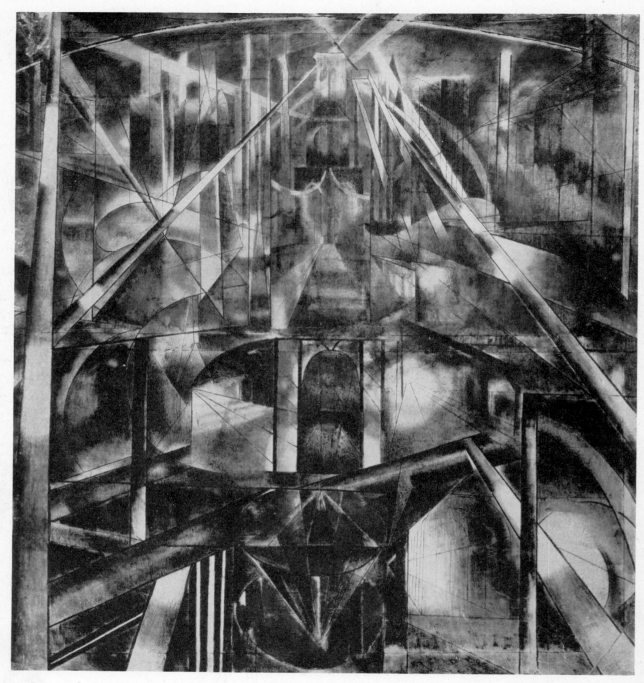

17

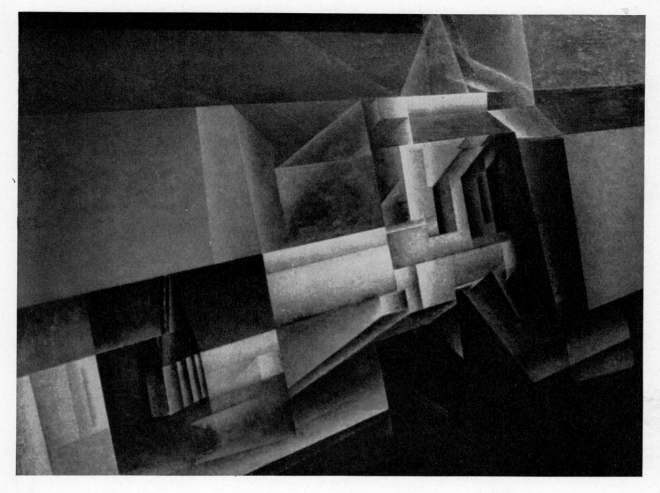

18 LYONEL FEININGER
ZIRCHOW-7, 1917, oil 31½ x 39½".
Collection the Artist. Born New York
1871. Lives in New York.

— A medieval church, met with in a village near the Baltic. Deeply impressed by its simple grandeur I composed, after sketches made on the spot, several paintings of which this is the seventh and final one. In it all parts are spatially balanced; details reduced or eliminated. Thus I was able to reproduce my inner vision of the subject. — Lyonel Feininger, 1943.

17 JOSEPH STELLA
BROOKLYN BRIDGE, 1917-18, oil
85 x 75". *Collection Yale University Art
Gallery.* Born Italy, 1880. Lives in Flush-
ing, N. Y.

— *Brooklyn Bridge* had become an ever growing obsession ever since I had come to America. Seen for the first time as a weird metallic apparition under a metallic sky, out of proportion with the winged lightness of its arch, traced for the conjunction of worlds supported by the massive dark towers dominating the surrounding tumult of surging skyscrapers with their gothic majesty sealed in the purity of their arches, the cables, like divine messages from above, transmitted to the vibrating coils, cutting and dividing into innumerable musical spaces the nude immensity of the sky, it impressed me as the shrine containing all the efforts of the new civilization, *America* — the eloquent meeting point of all the forces arising in a superb assertion of their powers, in *Apotheosis.* — Joseph Stella, from *The Brooklyn Bridge (A page of my life)*, 1928.

19 CHARLES SHEELER
BARN ABSTRACTION, 1917, black conté crayon 14¼ x 19½". *Collection Mr. & Mrs. Walter C. Arensberg.* Born Philadelphia, 1883. Lives in Tarrytown, N. Y.

— Forms assembled with a primary view to their function are invariably of interest to me. For example, the Early American farm buildings which were built to serve their purpose without the impediment of recollections of architectural orders. — *Charles Sheeler, 1943.*

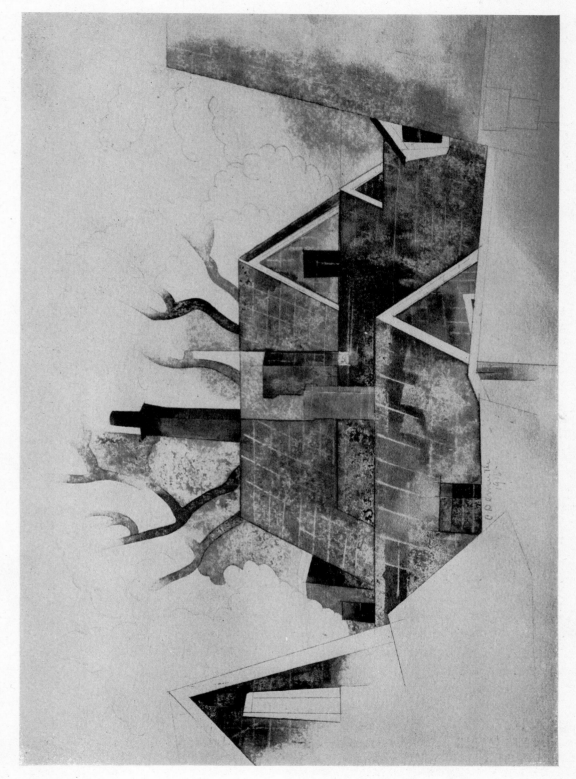

20 CHARLES DEMUTH
RED CHIMNEYS, 1918, water-color 9¾ x 13¾". *Collection Phillips Memorial Gallery.* Born Lancaster, Pennsylvania, 1883. Lived in Lancaster. Died 1935.

— Across the final surface — the touchable bloom — if it were a peach — of any fine painting is written for those who dare to read that which the painter knew, that which he hoped to find out, that which he — whatever! —Charles Demuth, "Across a Greco Is Written," *Creative Art,* September, 1929.

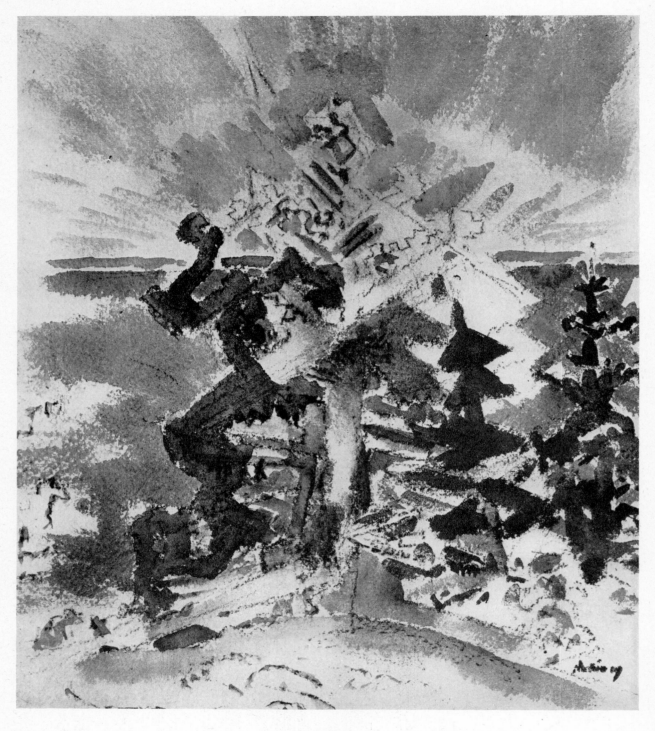

21 JOHN MARIN
TREE, SEA, MAINE, 1919, water-
color 16¾ x 13¾". *Collection Mr.
Alfred Stieglitz*. Born Rutherford,
New Jersey, 1870. Lives in Cliffside,
New Jersey.

— My work is meant as constructed expressions of the inner senses responding
to things seen and felt. One responds differently toward different things; one
even responds differently toward the same thing. In reality it is the same thing
no longer . . . — John Marin.

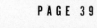

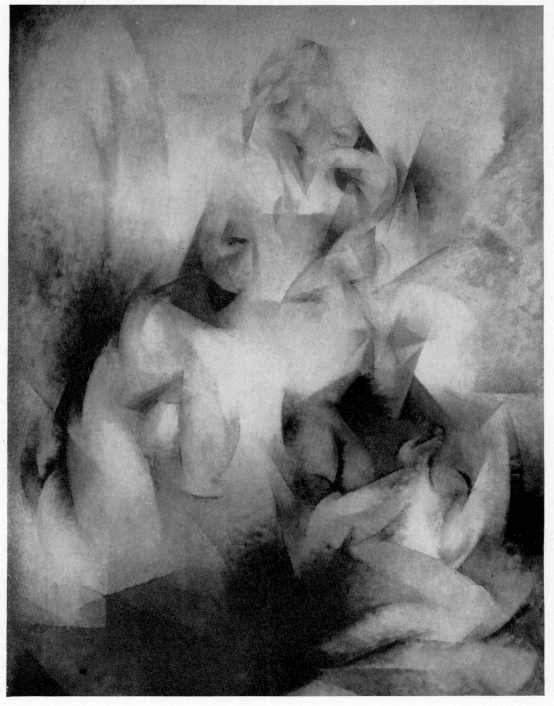

22 S. MACDONALD-WRIGHT
SYNCHROMY IN BLUE AND
ORANGE, 1916, oil 40 x 30". *Collection Mr. Alfred Stieglitz.* Born
Charlottesville, Virginia, 1890. Lives
in Santa Monica, California.

— Synchromism was the first movement to adumbrate the use of formal color in
abstract design. My aims were to compose in depth by means of the natural
three-dimensional extensions of the chromatic gamut. I still feel that a related
color design is the characteristic expression of our age. — S. MacDonald Wright,
1944.

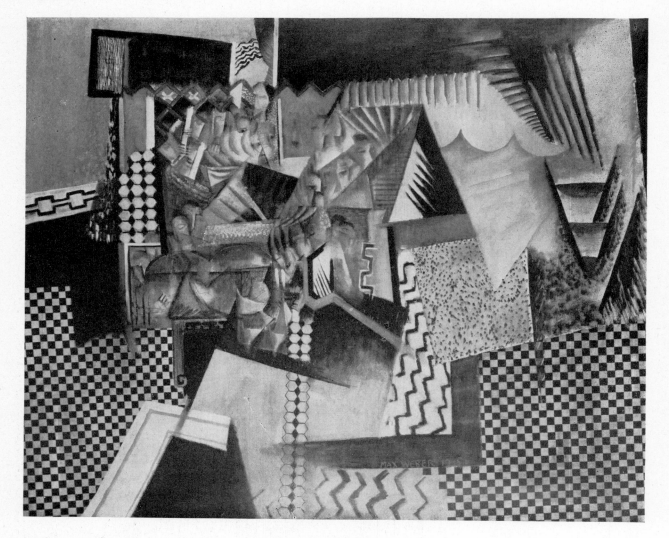

23 MAX WEBER
CHINESE RESTAURANT, 1915,
oil 40 x 48". *Collection Whitney Museum of American Art.* Born Byalostok, Russia, 1881. Lives in Great Neck, N. Y.

— On entering a Chinese Restaurant from the darkness of the night outside, a maze and blaze of light seemed to split into fragments the interior and its contents, the human and inanimate . . . To express this, kaleidoscopic means had to be chosen. The memory of bits of pattern were less obvious than the spirit and festive loveliness and gaiety — almost exotic movement. Therefore, the glow, the charm, the poetry of geometry was stressed. — Max Weber, from *Max Weber Retrospective Exhibition*, Museum of Modern Art, 1930.

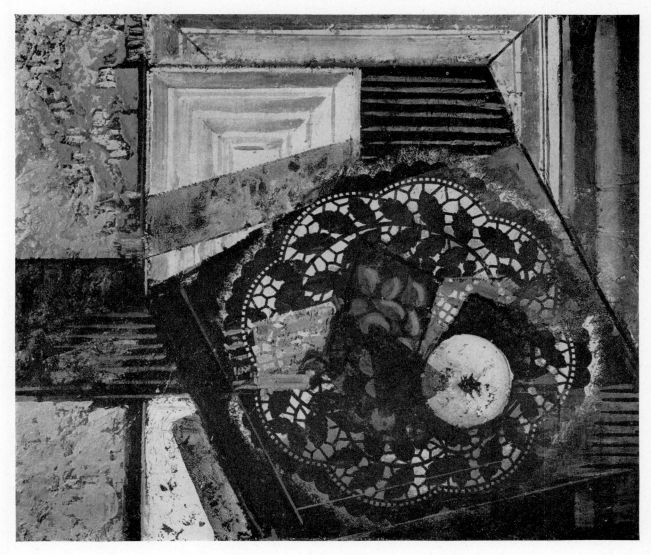

24 ALFRED MAURER
ABSTRACT STILL LIFE WITH
DOILY, oil 17¾ x 21½″. *Collection
Phillips Memorial Gallery*. Born New
York, 1868. Lived in New York. Died
1932.

— The artist must be free . . . Nature must not bind him or he would become
more interested in the subject before him than in the things he feels need expres-
sion. In my case where I am interested in color volumes, I consider the total
values. That is why my pictures differ from the scene which they might seem to
represent. — Afred Maurer, from *The Forum Exhibition of Modern American
Painters*, March, 1916.

25 GEORGIA O'KEEFFE
WHITE BARN, CANADA, 1932, oil 16 x 30". *Collection the Artist.* Born Sun Prairie, Wisconsin, 1887. Lives in New York and Taos, N. M.

26 ARTHUR B. CARLES
COMPOSITION, 1940, oil 34 x 39". *Collection the Artist.* Born Philadelphia, 1882. Lives in Chestnut Hill, Pennsylvania.

— *White Barn, Canada* is nothing but a simple statement about a simple thing. I can say nothing about it with words that I have not said with paint. — Georgia O'Keeffe, 1944.

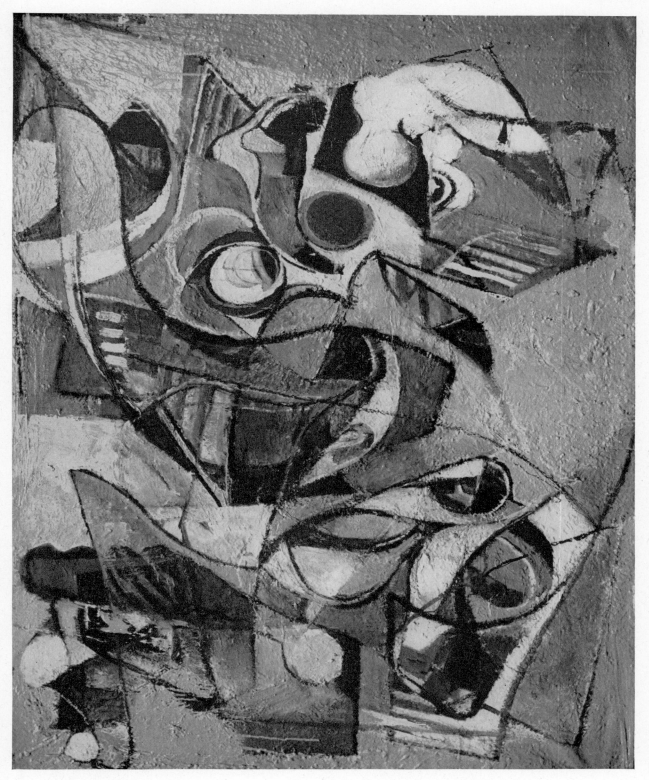

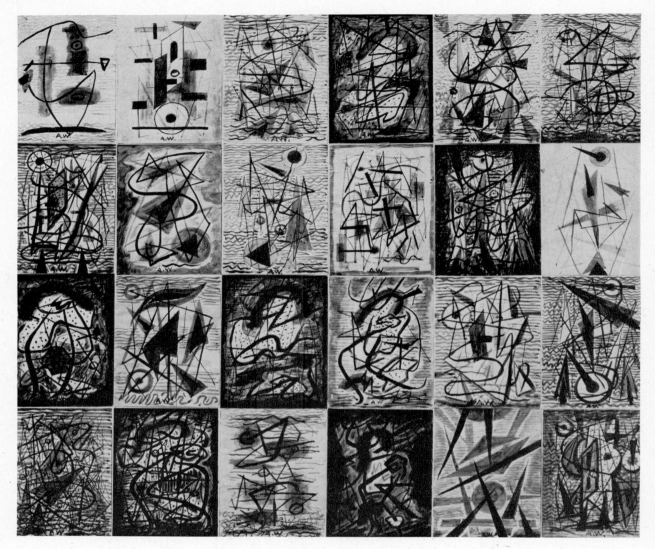

27 ABRAHAM WALKOWITZ
CREATION, 1918, water-color and ink 36 x 46". *Collection the Artist.* Born Tuman, Siberia, 1880. Lives in Brooklyn, N. Y.

— Pure abstract art is wholly independent of picturization in any form or of any object. It has a universal language, and dwells in the realm of music with an equivalent emotion. Its melody is attuned to the receptive eye as music is to the ear. — Abraham Walkowitz, 1944.

28 MAN RAY
ADMIRATION OF THE OR-CHESTRELLE FOR THE CINE-MATOGRAPH, 1919, airbrush 26 x 21½". *Collection Museum of Modern Art.* Born Philadelphia, 1890. Lives in Hollywood, California.

— Working on a single plane as the instantaneously visualizing factor, the artist realizes his mind motives and physical sensations in a permanent and universal language of color, texture and form organization. He uncovers the pure plastic plane of expression that has long been hidden by the glazings of nature imitation, anecdote and other popular subjects. — Man Ray, *The Forum Exhibition*, 1916.

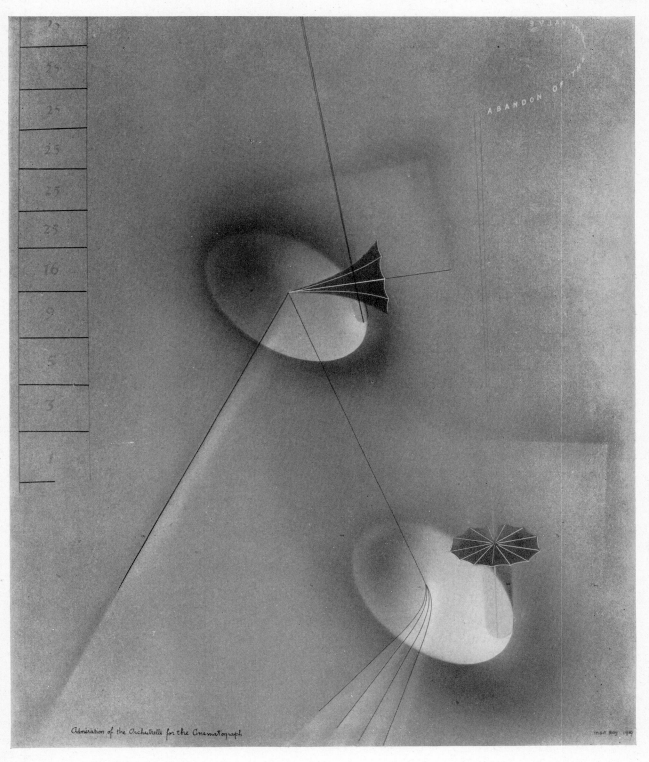

Admiration of the Orchestrelle for the Cinematograph

man Ray 1919

3 AMERICAN ABSTRACT PAINTERS

A LOW EBB of creative energy in the abstract field ushered in the twenties. A lack of esthetic impulse in contrast to the feverish activity of the environment pervaded the art atmosphere for over half a decade, until economic and educational factors eventually absorbed the humors and cleared the air for a resurgence of creative drive.

Of the few younger men in whose hands lay the hopes for the future of twentieth-century art, Stuart Davis, converted to the new direction in 1921, infused his own vitality into the body of abstract art. Over the span of the twenties he was gradually joined by Vitlacil, Graham, Gorky and Matulka, the most alert of the newcomers. Many of the pioneers were still hewing essentially to the line of their precepts, although several occasionally slipped into the vernacular of realism. Despite the tradition of nonfigurative art established by *de Stijl*, the Bauhaus, and the constructivists abroad and by a few of our pioneers in the 'teens, the preference of American painters at this time was entirely for nature as a point of departure, for abstractions derived from the representational. It was for still younger people who joined the vanguard in the thirties to clean the slate again, the principles of nonfigurative art having great appeal for them and gaining many adherents. Surrealism, the offshoot of the twenties in Europe, did not touch America for almost ten years after its inception abroad.

In the meantime only on the rarest occasions did abstract painters here have the opportunity to display their works, and those who continued painting, deprived of even the barest means of subsistence, supported themselves by teaching or by taking jobs far removed from art. Though there were sufficient reasons, both esthetic and social, for a concerted effort toward those group activities that might have bolstered their own and public morale, they were too dispirited to make the attempt. Tentative gestures were made and plans discussed, but nothing concrete materialized.

Sponsoring them were only a few New York galleries: Stieglitz, whose campaign was now confined to solidifying the position of his own group, a policy he continues today; the Little Review Gallery, extending to the exhibition field the editorial policy of its magazine; the Daniel Gallery, which now under the mentorship of Alanson Hartpence included Peter Blume and other young men of promise. (This gallery held an exhibition in 1925 arranged by Mme. Galka Scheyer, of the *Blue Four*, Feininger, Klee, Kandinsky and Jawlensky.)

In the twenties, though several new museum groups entered the scene, they were under the same spell as the artists. The *Société Anonyme*, founded by Katherine Dreier and Marcel Duchamp, distinguished itself in a series of exhibitions, accessions and symposia that encouraged the new spirit, making an auspicious start. Its activities, however, were very much curtailed within a few years, and the opportunity to fill a growing public need which developed toward the end of the decade passed to the Museum of Modern Art. In 1926 the *Société* arranged a comprehensive exhibition of advanced art at the Brooklyn Museum. Only recently, in 1943, Miss Dreier presented the *Société Anonyme* Collection to Yale University.

The Whitney Studio Club, organized in 1916, later the Whitney Studio Gallery, and eventually the Whitney Museum, devoted all of its energies to the exhibition, sale and purchase of American art, although abstract painting, until the opening of the museum in 1930, was given little space. In the earlier phase selection was made on a proportional basis, and since abstract artists were outnumbered some one hundred to one, their works appeared in this ratio.

Under the conditions that prevailed and in the face of a mounting prosperity surrounding them, it is not surprising that artists who could not survive without support, approval and companionship turned their backs on the difficult path of abstractionism.

Generally speaking the progressive collector had not yet got around to abstract American art. The critic and collector Hamilton Easter Field, who had performed the creative task of uncovering and revaluating American primitive art, especially that of the obscure itinerant limner, extended his interest to include contemporary American painters whom he tried to direct into this tradition.

Evidently overlooked by him was the recognition of plastic analogies, only recently effected, between this primitive tradition and that of twentieth-century abstract art. Both primitive in nature, they are at opposite poles of sophistication: yet they have suffered a similar fate from the appreciative angle. The limner, although in demand in his day, was regarded as a hack, a purveyor of utilitarian objects, rather than a creator of art. He was ignored by people who could afford fashionable portraits from abroad, or, as an alternative, imitative ones at home. In turn, the American abstract painter was also overlooked, at least for a time, while the affluent collector went abroad. However, to consider the acquisitions of the collector in both epochs is to note a change in pattern. For while the portrait painting brought into early America proved of dubious value, collectors now returned at times with Seurats, Cézannes, Picassos, the foundation and structure of those esthetic values which in the twentieth century are international in scope. That fine examples of twentieth-century American art were also available was evident to the connoisseur Ferdinand Howald, who in the twenties combined on an even basis, European moderns with American pioneers.* After 1929, collectors, affected by the "crash," curtailed the purchase of European art and turned to the work of native artists. The paradox of the boom years during which these artists suffered, was reversed, and after the financial crisis, American abstract artists came upon better days, together with artists in all fields.

In the meantime the forces of time and habit had been functioning. Effortless training of the eye through everyday experience helped immeasurably to break down those inevitable prejudices that come with resistance to change. A vast majority of people not conditioned in advance by personal need or imaginative experience could accept only by degrees a revolution in esthetics unequalled in the history of man.

Influences derived from twentieth-century art, cubist and geometric abstract art in modern architecture, industrial design, typography, now touched the daily lives of the people in innumerable ways. The esthetics of these forms, many of which could be manipulated and their effectiveness directly demonstrated through use, were for the most part immediately acceptable to a public always quick to respond to the products of scientific research and invention. The original values in the works of art from which these forms derived, though not acceptable to a wide audience at the time they were created, could now be more readily understood. Commonplace experience had helped many observers over the difficult hurdle to appreciation and to a more penetrating and conscious understanding of the character of their own time.

The opening of the Museum of Modern Art in 1929 proved an event of far-reaching significance. Through its formidable list of founders, who were prominent socially and financially, this institution at

* Now the Howald Collection, Columbus Gallery of Fine Arts.

last provided the stamp of official museum approval necessary to bring in the timorous, the hesitant and the diffident who by now hovered like a host on the outskirts of modern art. Under the able directorship of Alfred H. Barr, Jr.,* its wide educational program, including brilliant exhibits, both European and American, and its uncanny ability to glamorize esthetics, have all helped to make it a powerful force for modern art. Comprehensive catalogues of the Museum exhibits have a nationwide public. Broadening its accessions policy, the Museum has recently added many American abstract and surrealist pictures. In the fifteen years of its existence the number of practicing artists in both these fields has increased many times.

This flowering, however, is not attributable to the Museum alone, for other agencies were instrumental in accelerating the transition to advanced concepts. One of these came at the depth of the depression. Under the aegis of the New Deal, the huge Federal Art Project got under way, and this was a signal factor in the encouragement of a wide variety of artists embracing all schools. A measure of security and an accredited place in relation to the social body did much for their self-assurance. Naturally abstract painters benefited with the others, and were assigned either to the easel division or to murals for public institutions.

Many of the younger American painters, having become absorbed with conceptual relationships, resolved their esthetic problems into nonfigurative abstraction. Severe discipline and complete objectivity in adhering to fundamental issues of plastic experience caused them to reject the figurative near-abstractions that had until then been the sole preoccupation, with very few exceptions, of the abstract painters here. Well informed of the changes abroad, the nonfigurative painters allied themselves to tenets of absolute form which were evolving in Europe. A few years earlier, in 1930, a revived interest in abstract art was strongly felt in Paris, where a group had formed in which the majority of members were nonfigurative painters. Their publication *Cercle et Carré*, under the direction of Seuphor and Torres Garcia, catalogued their first exhibit, which included works by leading international exponents, Mondrian and Arp among others. American participants were Stella and Rattner. Two years later the *Abstraction Création Art Nonfiguratif* group was formed by the same artist-leaders, again in Paris, and now among its charter members were the American painters Gorky, Holty, Dreier and Calder, also Albers and Moholy-Nagy of the Bauhaus, as well as Hélion and Seligmann, all of whom have since established residence here.

The *Abstraction-Création* group, then, was made up of international members. When, through the notorious program of cultural suppression in Germany, the Bauhaus was closed in 1934, a shift of its artists to other countries, especially to France, England and the United States, took place. With the momentum of this shift, a new group was formed in England in 1935 as an extension of the Paris *Abstraction-Création* group, and their publication was *Axis*. It was inevitable that America should be touched by this westward swing.

In 1937 a number of older abstract painters were joined by several former pupils of Hans Hofmann, the abstract painter, and after a series of meetings enlivened by heated discussions, the American Abstract Artists group was founded. From the start former Bauhaus artists participated in the exhibitions which are still an annual event, and later, exiles from France, such as Mondrian and Léger, also exhibited. Most of the group are nonfigurative painters and of its membership of about thirty, Albers, Browne, Greene, Hélion, Holty, Moholy-Nagy, Pereira and Reinhardt have paintings reproduced here.

The opening of the Solomon R. Guggenheim Foundation in 1939 was the largest single effort toward the promulgation of nonfigurative art in America. Of special interest in its permanent exhibition is a chronological continuity of the works of Kandinsky dating from the period of his early improvisations.

* Advisory Director since 1943.

Beyond the borders of New York the horizon of twentieth-century art has widened dramatically. The Arts Club of Chicago, originally organized under the guidance of Mrs. Rue Carpenter a score of years ago, retains under later leadership its active exhibition program allotting space to painters of the young schools. The Carnegie Institute at Pittsburgh has developed considerable prestige with its long list of annual international shows. If a small proportion of the pictures has been of an advanced nature, these few paintings have circulated to various cities with the rest and have acted as a stimulus to healthy controversy.

Museum policy broadened extensively as the more alert directors gradually sensed the stature of events about them. The Art Institute of Chicago, apart from its inclusion of stimulating exhibits and one-man shows, devotes a room to Chicago abstract artists in a yearly exhibit. The San Francisco Museum has long given space to the work of vanguard painters in its extensive exhibition program, and this year arranged the tour for a show, *Abstract and Surrealist Art in the United States*, in anticipation of this book. In years past the Oakland Art Gallery also held precursor exhibitions. Among other American museum activities are the installation of a contemporary room at Buffalo's Albright Art Gallery, and the exhibition at an increasing number of museums of one-man shows of abstract art and group shows consisting in part of advanced work. Organizations particularly active are the Cincinnati Modern Art Society, the Philadelphia Art Alliance and the Institute of Modern Art in Boston.

The response of colleges throughout the country is marked. Smith, Yale and other institutions have fine contemporary collections. For several seasons the Harvard Society of Contemporary Artists did commendable work. In addition to courses in art appreciation and contemporary art history, many colleges have artists in residence. At Black Mountain College, Albers, the former Bauhaus artist-educator, is in charge of an experimental art laboratory, and at the Institute of Design in Chicago, Moholy-Nagy, a former Bauhaus leader,* carries forward new principles in the fields of modern art and design. In Michigan, the Cranbrook Academy of Art is devoted almost exclusively to the new spirit. Another active educational institution is Mills College, where Feininger, Léger, Ozenfant and Archipenko were guest instructors for consecutive years. Sarah Lawrence, Bennington and many other colleges contribute to the list, while high schools and even primary schools, finding students responsive, are increasingly including courses in their curricula.

Some further idea of the constantly growing interest in modern art throughout the country may be gleaned from the Museum of Modern Art traveling exhibition schedule. Almost one hundred centers have booked shows, including many examples of abstract art as well as a section of the exhibit *Cubism and Abstract Art*, a major event at the Museum in 1936. This exhibit featured European work only, while the Whitney Museum held a large show in 1935 called *Abstract Painting in America*, in which pioneers and younger American painters participated.

From 1927 to 1942, New York University housed the comprehensive A. E. Gallatin Collection in the students' library. On several occasions Mr. Gallatin published small but excellently written, illustrated brochures on the collection. Specializing in the abstract art of many countries, this collection has for its nucleus perhaps twenty examples of Picasso's work. Together with its recent additions of American nonfigurative work, it is now permanently installed in the Philadelphia Museum of Art.

Active for more than twenty-five years, the Phillips Memorial Gallery in Washington has steadily enlarged its collection to include advanced American painting; in Merion, Pennsylvania, the vast collection of the Barnes Foundation contains many examples of the work of Demuth and others.

In the early thirties, the Downtown Gallery and then the Artists' Gallery in New York began to

* Other Bauhaus leaders now here are Dr. Walter Gropius and Marcel Breuer on the faculty of Harvard, and Mies van der Rohe on the faculty of the Illinois Institute of Technology.

sponsor American abstract art; more and more galleries have followed suit, and today there are twenty-odd in the vanguard.

Within the space of twenty years the change in the attitude of the public toward twentieth-century art and in the number of practicing artists and standards of their work has been both cumulative and compelling, an indication of its vitality, its immediacy, and its ability to furnish those esthetic gratifications which are so necessary for spiritual survival. The dominant personalities that have emerged present a wide range of tendencies, interchanging and expanding in many directions.

Similar propensities on the part of artists draw them into similar channels. Many abstract artists conceive their works in relation to some stage of cubism. Stuart Davis, a veteran in the field and the dean of the younger generation, never departs from nature, although he paints passages which reach far into pure abstraction. *Ursine Park* (29), a vivid scene of reconstructed reality, consists of an arrangement of sharply colored, irregular shapes and angular calligraphic line and is as American as a New England patchquilt, though having the pattern of late cubism. John Graham, another veteran abstract painter, builds his picture *Studio* (30) upon a structural order and use of pigment related to Picasso's 1928 period. The metamorphosed *Head* (32) by Byron Browne and the powerful structure of Krassner's *Composition* (31) have the accents of even later cubist work, while Mercedes Carles' *Still Life in Red and Green* (36) is solidly based upon an earlier cubist period transmuted to her own pictorial needs. Kepes, in his equilibrated *Aerial Photography-China* (37) introduces the oblique organization of Gris. In this picture the media of photography and painting are ingeniously wedded through collage. Crawford's mechano-morphic *Grain Elevator from Bridge* (38) reflects the forms of the industrial age in a spirit akin to Léger's.

Three painters who have incorporated elements that relate to futurism as integral components are Rattner, Wolff and Molzahn. Rattner in *April Showers* (34) has established kinetic continuity, not through painting an image in progressive stages of action but by presenting a series of figures which suggest successive images because of their ability to lead the eye across the canvas. In Wolff's *Kinetic Light* (33), lines of force playing through lights and darks create dynamic interaction. Molzahn's *Icarus* (35) is composed of a maze of interpenetrating planes in the midst of which juxtaposed forms levitate. At this latter point, which is the point of transposition, the focus of the spectator swings camera-like, registering facades of geometric light patterns which recede in all directions. The sharply delineated light here in contrast with the diffused light in Wolff's picture demonstrates the polarity obtainable within a given direction.

Hofmann, occupied by his varied teaching duties, nevertheless finds time to do many pictures. His *Painting* (51) is both abstract and expressionist; painted with such unpremeditated verve as to resemble the automatist method of surrealism. Hofmann and Pollock (80) paint with a similar technique — yet they do not appear in the same category here, the line of demarcation being due to difference of degree rather than of kind. The respective characteristics of their work are spontaneity versus obsessiveness.

Merging of abstract and expressionist streams is also apparent in the paintings of other artists, each achieved in its own way. Schnitzler has organized *1942* (40) in writhing, agitated, but solid forms with subtle variations of color and impasto, while the interlocking areas of surface texture in Price's *Abstraction* (41), imbued with the feel and color, the virility and earthiness of his more representational ranch subjects, are equally romantic. In Knath's *Moonlight, Harbourtown* (42), and Roesch's nighttime picture, *Midtown Manhattan* (43), the overtones of expressionist technique and the tensions and structure of early cubism share in unifying the respective pictures. Although it is almost pure abstraction, both abstract and surrealist elements are merged in Motherwell's *The Spanish Prison* (39). Motherwell was

associated with the French surrealists from 1940 to 1942, and his own words clarify the issue of a possible compatibility between these two seemingly opposing directions.

The preceding pictures are figurative, abstracted from nature and to a varying degree representational. The following group belongs to the category of nonfigurative art, no longer representational; though some of these pictures may still derive from nature, most are purely abstract in genesis and all are purely abstract in form.

Moholy-Nagy's *Space Modulator in Plexiglas Ch 4 1941* (44) utilizes a two-plane surface: forms appearing on the transparent plane are enhanced by natural shadows cast on the lower plane. Further interest is provided by shadows varying according to changing light. Pereira also uses the double plane, but paints on both surfaces, which are pictorially interrelated. Shadows here, too, play their part in the integration (45).

Bertoia's graphs are generally imaginative conversions of interstellar trigonometry. They are registered through a process of line and color pressings not unrelated to block painting but unique to each picture. The rectilinear predominates in *Monoprint* (46). Conversely, convoluting forms spiral their way through Ferren's *Development in Multiplicity* (47).

Hélion, whose home has been in America for the past ten years, had been an artist-leader of *Abstraction-Création* both in Paris and London. His *Composition* (48), based on principles of suspension, is in a sense a painted mobile. The narrow passageways allow the eye to circulate in and around the librated forms, and as a result a sensation of relative motion is created. Recently, after his escape from a German prison camp, about which he has written an absorbing book, Hélion turned to a more literal realism, not unrelated to the post-World War attitude of Léger in 1921.

In the following three nonfigurative paintings, the results, obtained through different means, have associations with representation. In one, a painting by Albers, a consistent painter of pure abstraction, the *a posteriori* image supplied the title, *In the Water* (53). Holty begins with pictorial relationships which he redirects, and if images of nature suggest themselves he develops them toward the representation suggested. In this case his painting becomes figurative abstraction. If images of nature do not suggest themselves, as in his transitional *Improvisation* (50), the painting remains nonfigurative. While Holty is not in sympathy with surrealism, his approach is partly through one of its avenues — that of free association. Greene's painting is nonfigurative both in origin and form. Entitled *Blue Space* (54), it nevertheless resolves itself into a picture in which an after-image suggests vestiges of an artist's studio. This association with nature apparently did not occur to the painter.

The nonfigurative paintings of Reinhardt often combine the classic with the romantic. His *Red and Blue* (55) is disciplined, while in other paintings he conceives amorphus forms with great freedom and spontaneity. Further, both traditions occasionally appear in the same picture.

A group of the highest integrity has formed around John Entenza, editor of *Arts & Architecture* in Los Angeles. Charles Eames, architect and designer; Herbert Matter, photographer; Ray Eames, Bertoia and Mercedes Carles, artists; and others have pooled their talents and efforts in a co-operative venture, a war project that has developed a process for molding laminated bentwood forms. Their products, splints for the wounded, are organic abstractions in which esthetics and science meet on the plane of utility.

The work of the artists in this chapter runs the gamut from figurative to completely nonfigurative art. From the readily identifiable representation of Solman and Crawford through progressive stages to the geometry of Bertoia and Reinhardt, they graduate from one extreme to the other somewhat in the following order: Rattner, Molzahn, Knaths, Roesch, Graham, Browne, Davis, Kepes, Carles, Schnitzler, Krassner, Hofmann, Wolff, de Kooning, Motherwell and Price. Crossing over to the nonfigurative, a

very narrow separation at this point, we find: Greene, Howard, Albers, and finally Holty, Ferren, Pereira, Moholy-Nagy, Eames, Hélion.

While the second group is in the category of pure abstraction, these painters still do not approach the pure logic of Malevich's *White on White* nor Mondrian's ascetic tenets of sharply defined rectilinear arrangement, primary color, smooth texture and absence of light and shade. Although artists such as Holtzman, Glarner and Diller have incorporated the fundamentals of Mondrian's style, to a large body of painters Mondrian has not been a direct influence so much as a spiritual force, inspiring them to uncompromising standards.

It is evident that in the recent past the tendency has been away from pure geometric art. Nonfigurative painters as they deviate from exacting precepts introduce in their work gradations of color and texture, modeling, nongeometric curves and often biomorphic shapes. While these pictures still remain in the nonfigurative sphere, other painters of this nature are found to have carried their morphology into representation. Still others, disengaging themselves from the restraint and discipline of geometrical abstraction, have given themselves over to release and freedom, making pictures of amorphous character with technical means that at times parallels the automatism of surrealism. Some figurative abstract painters have begun to veer all the way from classicism into the romantic, adding elements which may best be described as the visualization of subjective experience. Because of predominantly surrealist overtones which gain the ascendency, works of this nature are no longer fundamentally abstract (85, 86). If the various directions taken by some point toward surrealism, this may be prompted by one or more conscious or unconscious motivations: the gratification of ambivalent tendencies, an overwhelming desire to embrace vital experiences as they unfold, or the need to reflect the nervous character of our time.

29 STUART DAVIS
URSINE PARK, 1942, oil 20 x 40″. *Collection Downtown Gallery.* Born Philadelphia, 1894. Lives in New York.

— *Ursine Park* was painted from studies made directly from landscape in Gloucester, Mass. Instead of the usual illusionist method, the emotions and ideas were equated in terms of a quantitatively coherent dimensional color-space system. Through this method the embodiment of the idea becomes more specific in its terms and more direct in emotional expression. — Stuart Davis, 1944.

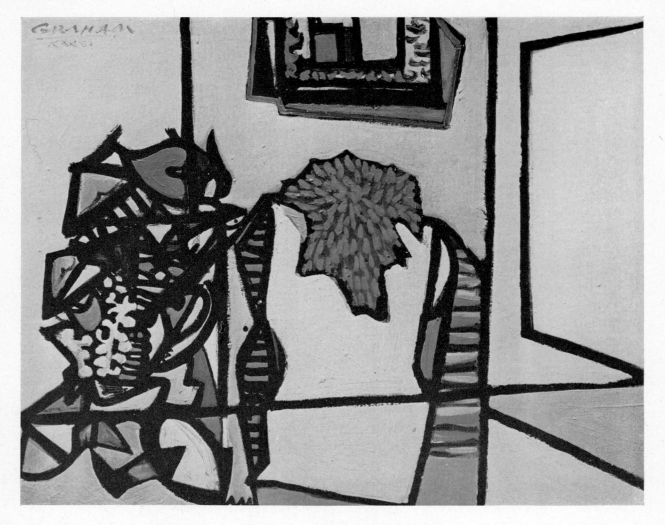

30 JOHN D. GRAHAM
STUDIO, 1941, oil 24 x 30". *Collection Dikran Kelekian*. Born Kiev, Russia, 1890. Lives in New York.

— *Studio* is the fifth of a series. It started with a realistic interior consisting of an old armchair with a little lamb's hide thrown over its back, a green plant, a square antique mirror above the chair and secretaire to the right. Every subsequent painting of this subject became a further abstraction or summation of the phenomena observed. — John Graham, 1942.

31 LEONORE KRASSNER
COMPOSITION, 1943, oil 30 x 24". *Collection the Artist*. Born New York, 1911. Lives in New York.

32 BYRON BROWNE
HEAD, 1942, oil 14 x 12″. *Collection
the Pinacotheca*. Born Yonkers, N. Y.,
1906. Lives in New York.

— I have painted a head. Globular vortex of vanities. Since my work is always
more or less involved with the object, I prefer to describe its content as a symbol
rather than to discuss in a pedantic manner its plastic structure. — Byron
Browne, 1944.

33 LT. ROBERT J. WOLFF, U.S.N.
KINETIC LIGHT, 1941, casein tempera 31½ x 25¾". *Collection the Artist.* Born Chicago, 1905. Lives in New York.

— We are used to thinking of images as things, as objects. Upon looking out on a busy street the first glance sees everything at once. Sustain this glance, and extend it into prolonged perception. There is another kind of image here, total, perpetual and self-transforming. Painting, since Cezanne, has destroyed the object to allow us this power of total perception. Painting now must provide the kinetic image, the life symbol. — Robert J. Wolff, 1944.

34 ABRAHAM RATTNER
APRIL SHOWERS, 1939, oil 32 x 39½". *Collection Mr. & Mrs. Roy R. Neuberger.* Born Poughkeepsie, N. Y., 1895. Lives in New York.

— *April Showers* — city streets, people, fuse together. Blacks of enamel or of velour, wet, fresh, clean. The light an iris-like aura of jewel colors. The ghostlike figures coming out of nowhere, then disappearing like an echo. The whole thing at once the festival, the dance, the dirge, where time is a tempo of spaces and shapes, where space becomes a tempo of written music in line and color, where the human being is sculptured in a frieze of floating humanity. *April Showers* is like a cathedral, the cloisters, the ogival arches, flying buttresses, candle flames, columns, and stained glass windows. — Abraham Rattner, 1942.

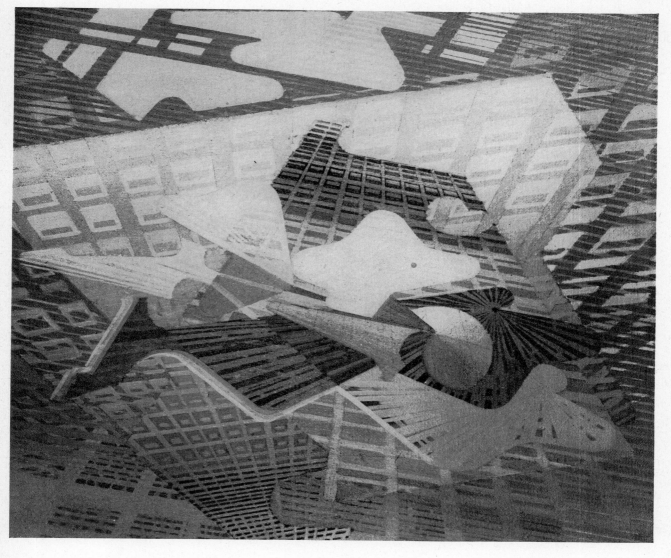

35 JOHANNES MOLZAHN
ICARUS, 1943, oil 34 x 40″. *Collection the Artist.* Born Duis-
burg, Germany, 1892. Lives in Chicago.

— *Icarus*, addressed to arouse dormant faculties in contemporary Man, is a passionate affirma-
tion of that new "tangent" of Man centering on the broadening and enhancing aspects which
the new space experience may have upon his concept of his world. — Johannes Molzahn, 1943.

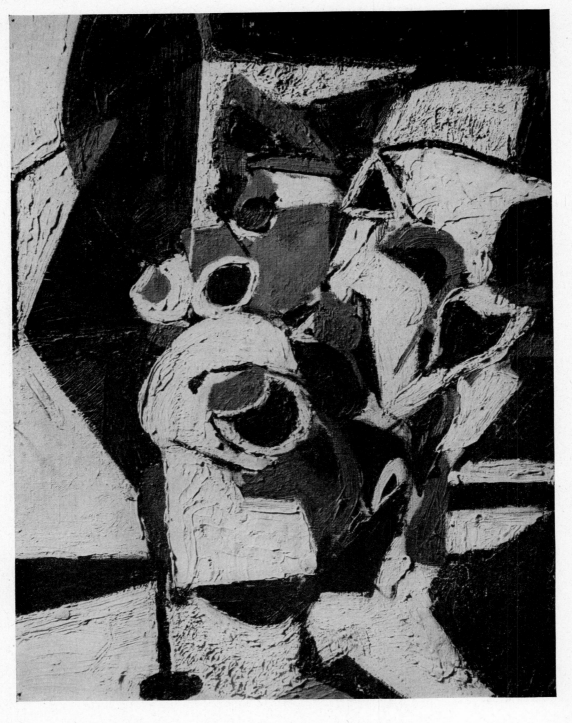

36 MERCEDES CARLES
STILL LIFE IN RED AND GREEN, 1935, oil 16 x 20".
Collection the Artist. Born New York, 1913. Lives in Santa
Monica, California.

37 GYORGY KEPES
AERIAL PHOTOGRAPHY — CHINA, 1942, collage 25 x 49". *Collection Mr. Herbert Ziebolz. Born Selyp, Hungary, 1906. Lives in Chicago.*

— Visual experience is not only the experience of pure sensory qualities. Visual sensations are interwoven with memory overlays. Each visual unit contains a meaningful text; it evokes associations with things, events, and feeling qualities . . . If the plastic organization and the dynamic organization of the meaning-signs are synchronized into a common structure, we have a significant weapon of progress. Because these images suggest a new thinking-habit, reinforced with the elementary strength of sensory-experience, the nervous system can acquire a new discipline necessary to the dynamics of contemporary life. — Gyorgy Kepes, 1944.

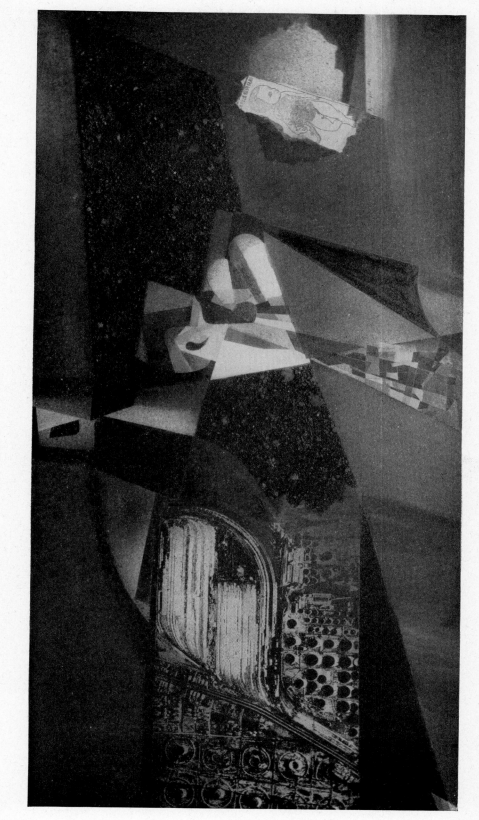

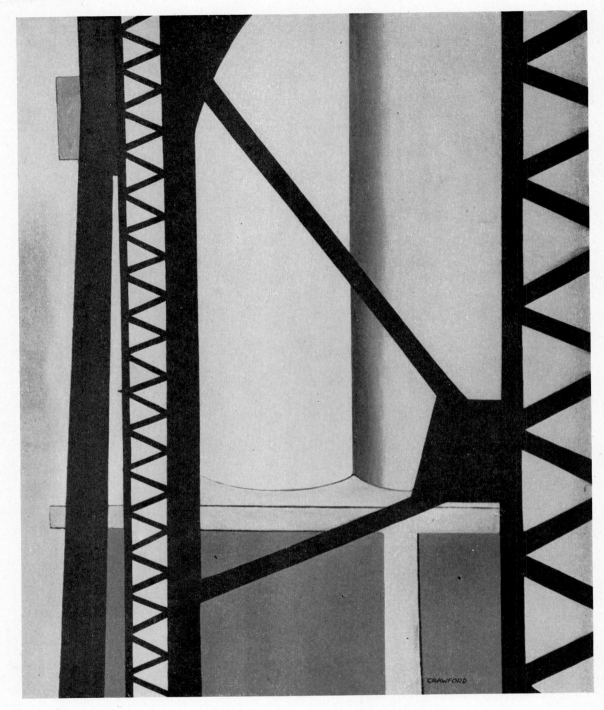

38 M/SGT. RALSTON CRAWFORD
GRAIN ELEVATOR FROM BRIDGE, 1942-43, oil 50 x 40". *Collection Downtown Gallery.* Born St. Catherines, Ont., Canada, 1906. Lives in Washington, D.C.

— The broad objectives in *Grain Elevator from Bridge* and my general orientation are probably clear to those familiar with 20th century art traditions . . . This picture is not a formal exercise but an effort to express in a contemporary idiom, something *about* the subject. — Ralston Crawford, 1944.

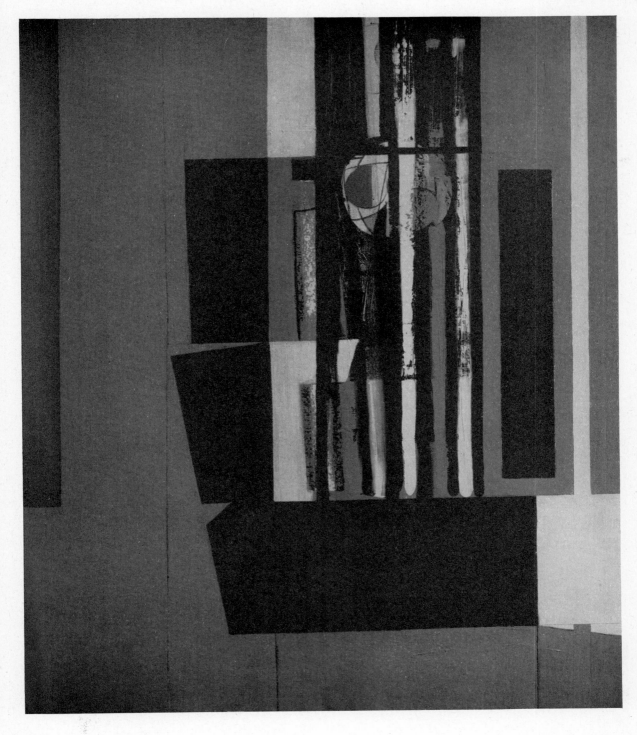

39 ROBERT MOTHERWELL
THE SPANISH PRISON, 1943-44,
oil 53 x 42". *Collection the Artist.* Born
State of Washington, 1915. Lives in
New York.

— The Spanish Prison, like all my works, consists of a dialectic between the
conscious (straight lines, designed shapes, weighed color, abstract language)
and the unconscious (soft lines, obscured shapes, *automatism*) resolved into a
synthesis which differs as a whole from either. The hidden Spanish prisoner
must represent the anxieties of modern life, the intense Spanish-Indian color,
splendor of any life. — Robert Motherwell, 1944.

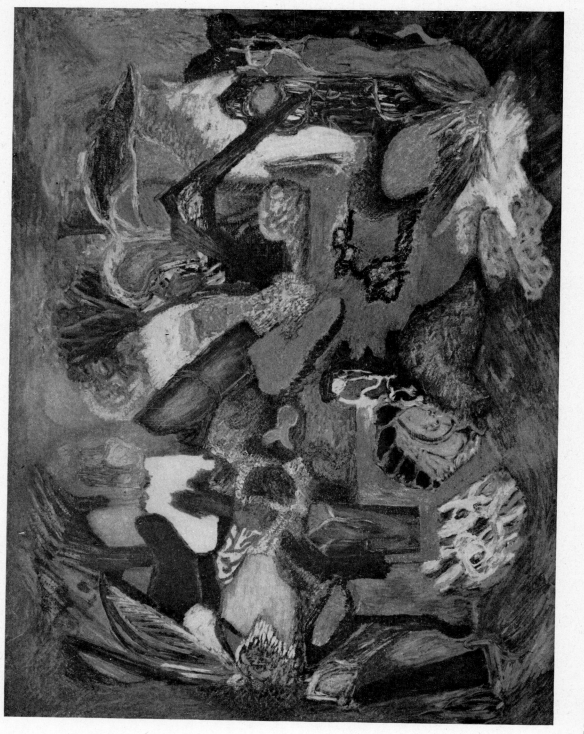

40 MAX SCHNITZLER
1942, oil 66 x 78″. *Collection the Pinacotheca.* Born Austria, 1902. Lives in New York.

— Movements of color, vibrations of mood are the elements and symbols expressed in this canvas. In this canvas there exists a personal expression of a world in motion integrated through shapes, forms, rhythm and color harmonies, though abstractly conceived. — Max Schnitzler, 1944.

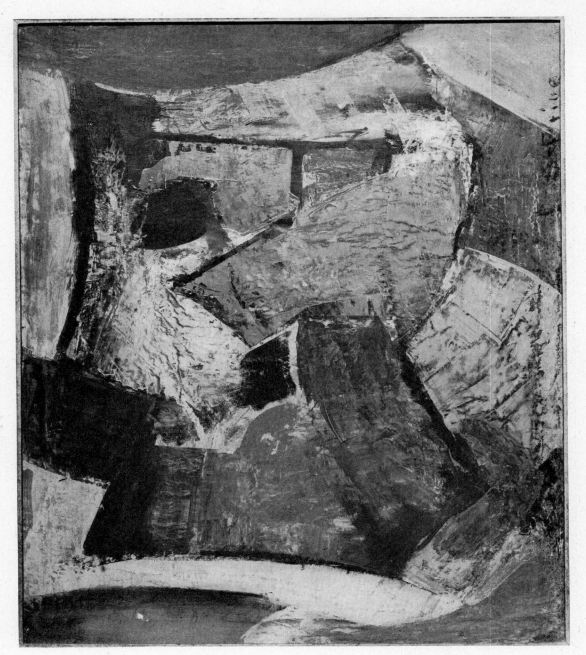

41 C. S. PRICE
ABSTRACTION, 1942, oil 28 x 34". Collection *Valentine Gallery*. Born, Iowa, 1874. Lives in Portland, Oregon.

— I have been trying to learn to paint for forty years but still don't know what it is all about. Have drifted all over the western part of the U. S., riding and working in the cow country, but have managed to keep at painting most of the time. — C. S. Price, 1944.

42 KARL KNATHS
MOONLIGHT, HARBOUR-
TOWN, 1940, oil 34 x 34". *Collec-
tion Phillips Memorial Gallery.* Born
Eau Claire, Wisconsin, 1891. Lives in
Provincetown, Massachusetts.

— This picture was the result of the
effort to get what was lovely and mov-
ing not by the reproduction of the
optical image but through the inten-
sification brought about by the con-
sistent use of expressive material. —
Karl Knaths, 1942.

43 KURT ROESCH
MIDTOWN MANHATTAN, 1939,
oil 36 x 48". *Collection the Metropoli-
tan Museum of Art.* Born Berlin, 1905.
Lives in Bronxville, N. Y.

— The so-called perspective in this
picture is a space organization which
assumes no onlooker. The city itself
stands, and looks in every direction,
up and down, left and right, into and
out of. Only the center, where the two
diagonals of the entire picture-space
cross, offer a moment of rest, an en-
trance to the whole mass of stone and
steel, hot and cold, surrounded by wa-
ter and air: *Midtown Manhattan.* —
Kurt Roesch, 1944.

44 L. MOHOLY-NAGY
SPACE MODULATOR IN
PLEXIGLAS CH 4 1941, 36
x 36". *Collection the Artist. Born Bor-*
sod, Hungary, 1895. Lives in Chicago.

— Revolutions in the arts usually come when changes in principles take place. The ideal situation exists when technological changes as well as changes of attitudes concerning imagery and content are integrated . . . I believe that *light painting,* executed on transparent plastics, is at a revolutionary stage in technique and attitude. It paves the way towards the projection of color, light and shadow on a screen instead of merely pigmenting a surface. — L. Moholy-Nagy, 1944.

45 I. RICE PEREIRA
DIFFRACTION #1, 1942, oil on glass and gesso 17 x 13″. *Collection the Artist.* Born Boston, 1905. Lives in New York.

— The problem here was to produce an integrated picture of plane and line with actual light and shadow. Two picture planes were used. The one on glass was painted on the back leaving some areas clear so that shadows are cast on the opaque back plane of the picture to produce a controlled synthesis of plane, line and shadow. The front plane of this painting is hammered glass which diffuses the light rays, the back plane oil on gesso panel. — I. Rice Pereira, 1943.

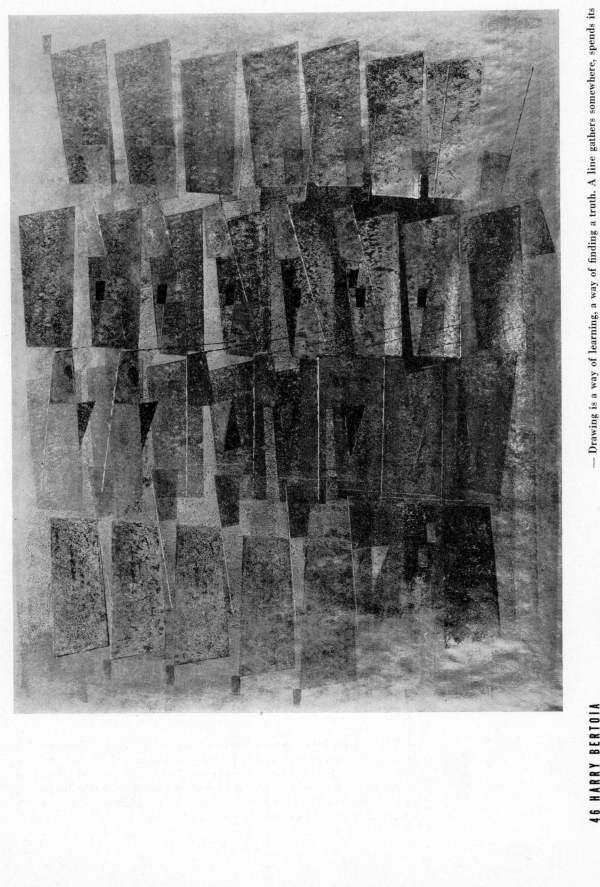

46 HARRY BERTOIA
MONOPRINT, 1944, oil 19 x 25″. *Collection the Artist.* Born
San Lorenzo, Italy, 1915. Lives in Pacific Palisades, California.

— Drawing is a way of learning, a way of finding a truth. A line gathers somewhere, spends its
energy and comes to an equilibrium equivalent to a life-cycle . . . Harry Bertoia, *Art & Archi-
tecture,* April, 1944.

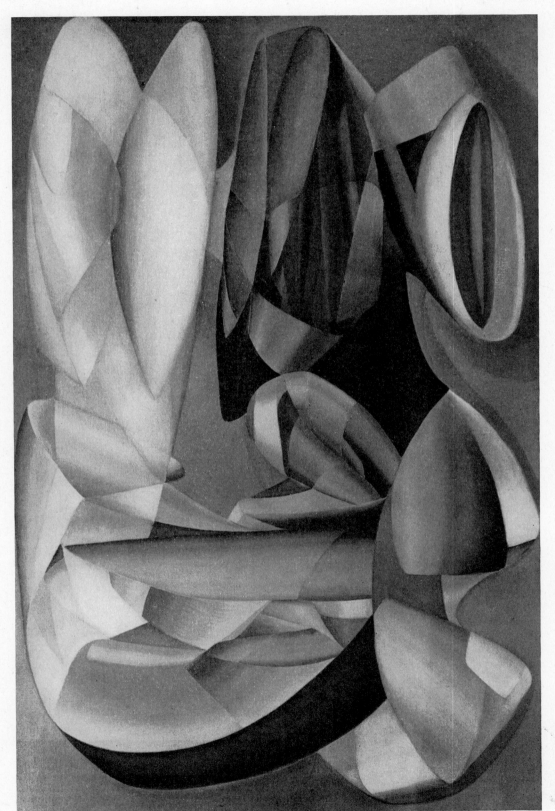

47 JOHN FERREN
DEVELOPMENT IN MULTIPLICITY, 1937, oil 27 x 40". *Collection Art of This Century.* Born Pendleton, Oregon, 1905. Lives in New York.

— My interest here was in multiplicity — the complexity lying beneath simplicity. I worked the shuttling inner forms to keep their subsidiary interest while contributing to the major swinging movement and counterbalanced the violence of movement by the use of quiet colors.
— John Ferren, 1942.

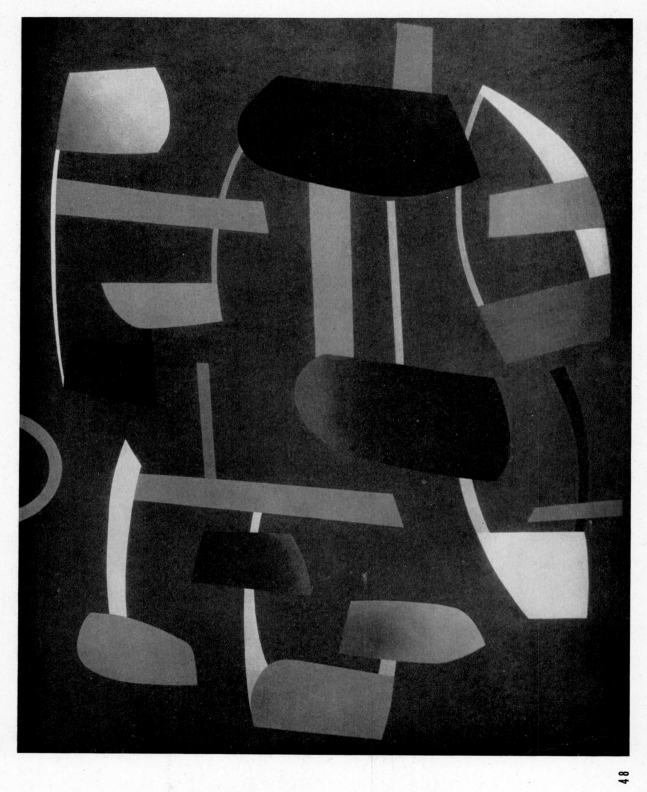

48 JEAN HELION

COMPOSITION, 1934, oil 52 x 64". *Collection the Valentine Gallery.* Born Couterne, France, 1904. Lives in Virginia.

— From the public's side, it has often been said that a recognizable subject is indispensable to establish contact between the artist and the spectator. If it were true, the crowd at the museums where all the works are figurative, would stop in front of the good pictures instead of stagnating as it does, in front of the mediocre. — Jean Hélion, *The Evolution of Abstract Art as shown in the Gallery of Living Art,* 1933.

49 CHARLES HOWARD

FIRST WAR-WINTER, 1940, oil 24½ x 34". *Collection San Francisco Museum of Art.* Born Montclair, New Jersey, 1899. Lives in San Francisco.

— The title of the painting *First War-Winter* is allusive, not descriptive. The general reference is ideographic. The presentation is in black and bright earth colors. — Charles Howard, 1944.

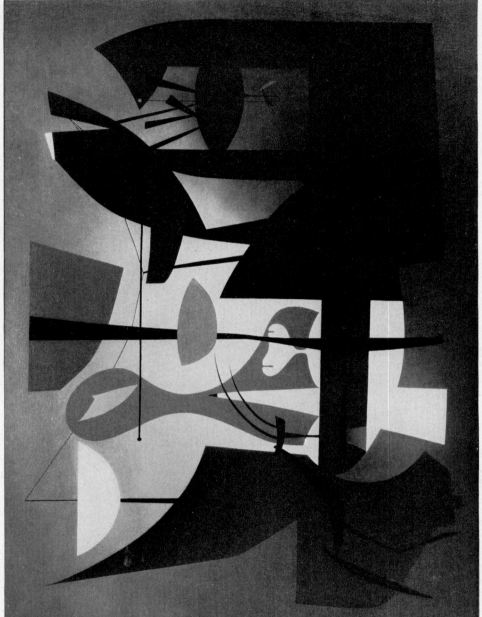

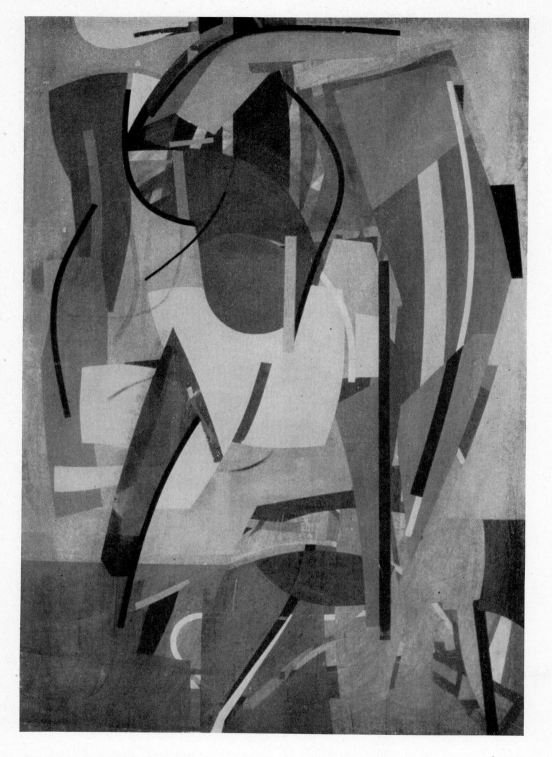

50 CARL ROBERT HOLTY
IMPROVISATION, 1942, oil 72 x
48". *Collection the Artist.* Born Frei-
burg, Germany, 1900. Lives in New
York.

— A large composition built on multi-colored patches and still in the state where
it can be entirely redirected by minor emphasis. It is plastically suggestive and
a refreshing way of working. Everything is possible — for the time being —
invention — establishing of opposition — refinement of relationship. — Carl
Holty, 1942.

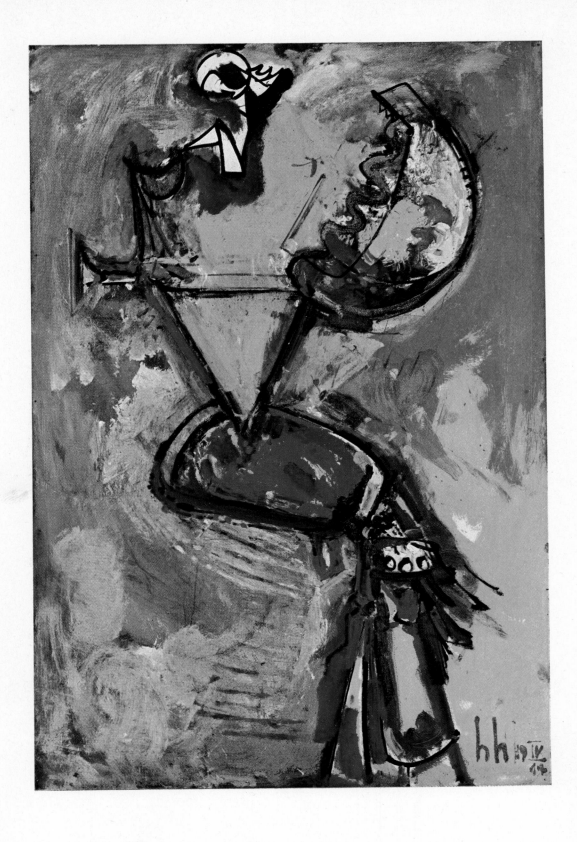

52 ALEXANDER CALDER
DRAWING, 1940, wash 22 x 30″.
Collection Willard Gallery. Born Philadelphia, 1898. Lives in Connecticut.

— I'll give you one word. The name of the drawing — it's "an alphabet" (of forms). — Alexander Calder, 1944.

opposite
51 HANS HOFMANN
PAINTING, 1944, oil 60 x 48″. *Collection the Artist.* Born Weisenburgam-Sand, Germany, 1880. Lives in New York.

— I paint from nature. Nature stimulates in me the imaginative faculty to feel the potentialities of expression which serve to create pictorial life — a quality detached from nature to make possible, a "pictorial reality." This is and must be esthetically independent of subject matter so that the creation may say what it has to say through purely pictorial means in the form of a spiritual unit which should exist and live for itself, as does nature, in accordance with the eternal law of the universe. — Hans Hofmann, 1944.

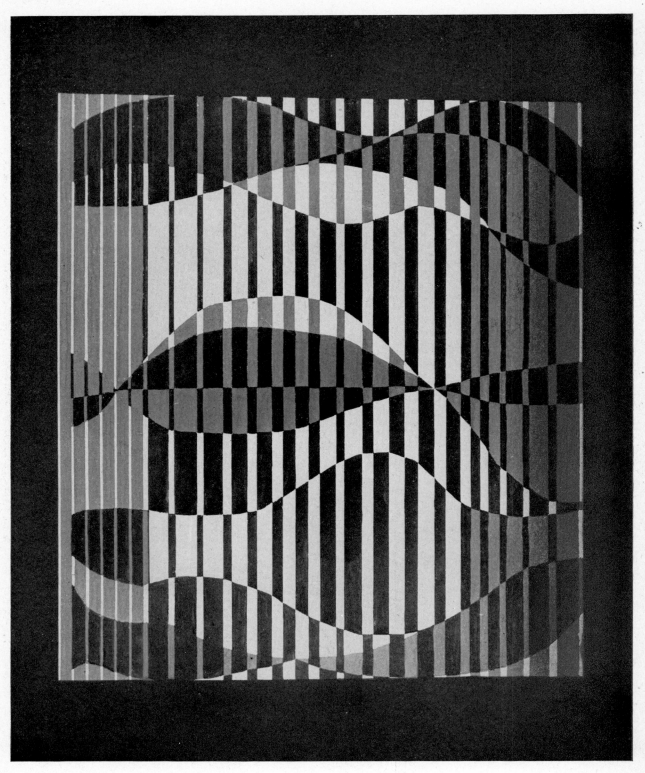

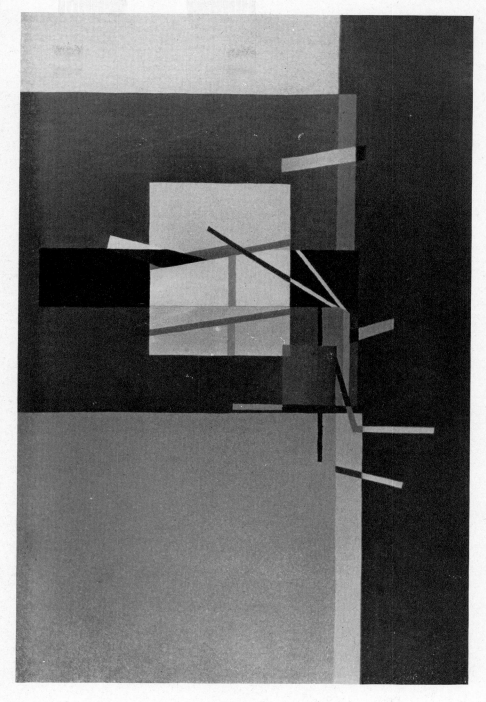

53 JOSEF ALBERS

IN THE WATER, glass painting 15 x 19″. *Collection the Artist.* Born Westphalia, Germany, 1888. Lives in Black Mountain, North Carolina.

— Despite the emphasized two-dimensionality of the design elements, the picture appears plastic and spatial, and even transparent, though the colors are opaque. This has been achieved through graduated distances between the horizontals and through interpenetrations which function as overlappings. This results in heaping and accentuation within the groups of equally colored stripes. Thus the whole produces an illusion of plastic movement. — Josef Albers, 1943.

54 BALCOMB GREENE

BLUE SPACE, 1941, casein 20 x 30″. *Collection the Artist.* Born Niagara Falls, N. Y., 1904. Lives in Pittsburgh, Pa.

— The effort here has been to create a compact element (slightly right of center) which by its activity controls the rest of the area of the canvas. This is accomplished partly by lines of tension which are established at various angles from the central unit, thereby creating a relationship between the active element and the surrounding space. — Balcomb Greene, 1942.

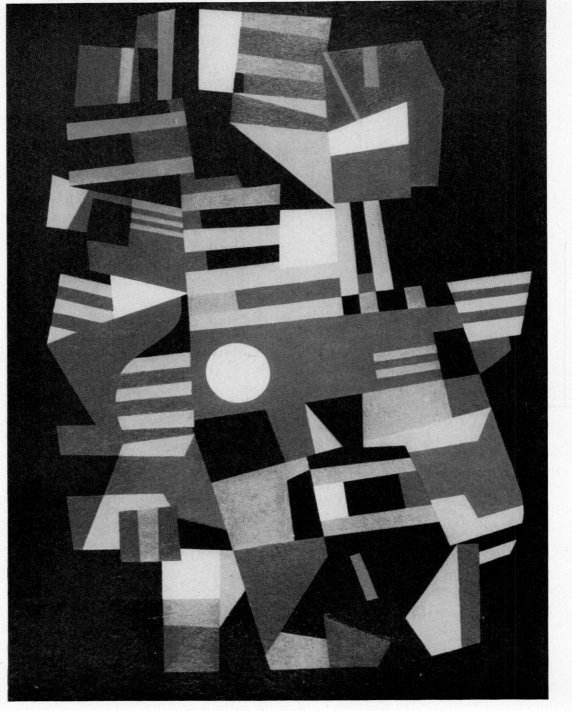

— *Red and Blue* is an abstract or non-objective work neither abstracted from nor representing any other objects. It means what its ordered forms and colors do. And it aims to be part of a growing body of imaginative plastic learning besides being a personal expression. — A. D. F. Reinhardt, 1944.

55 A. D. F. REINHARDT
RED AND BLUE, 1941, oil on celotex 24 x 30". *Collection the Artist.* Born Buffalo, N. Y., 1913. Lives in New York.

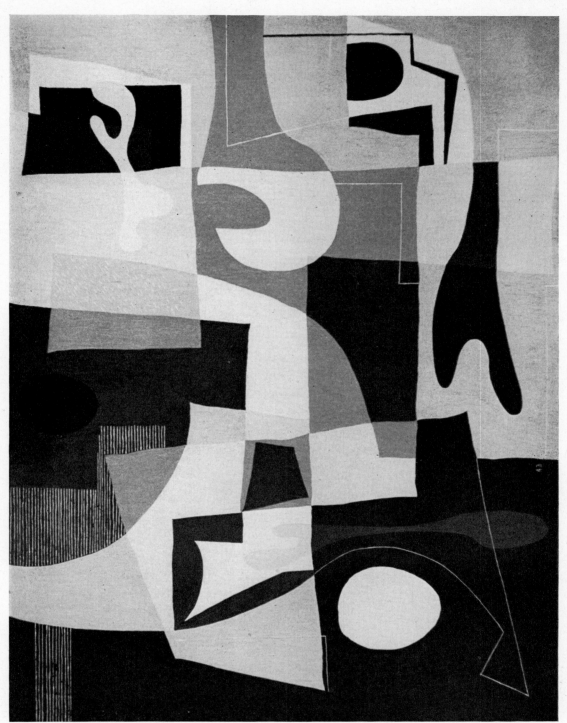

56 RAY EAMES
FOR C IN LIMITED PALETTE, 1943, oil 10 x 13½". *Collection Mr. Charles Eames.*
Born Sacramento, California. Lives in Santa Monica, California.

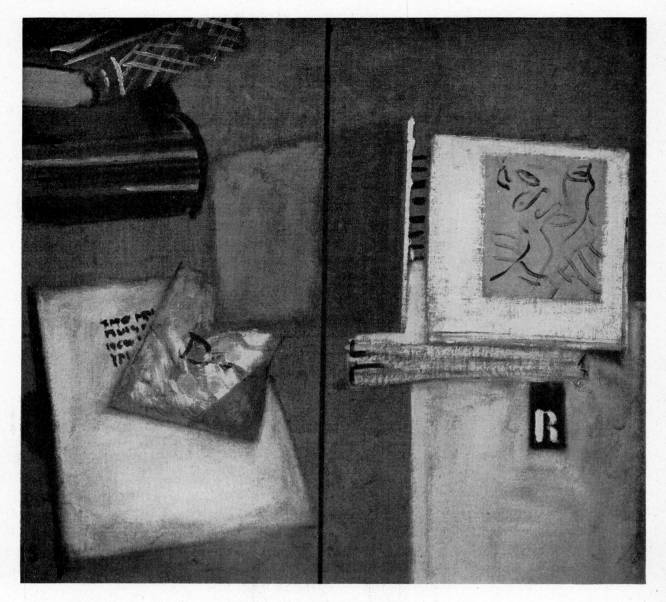

57 JOSEPH SOLMAN
GREEN MAGAZINE, 1940, oil
18½ x 19″. *Collection Phillips Memorial Gallery.* Born Vitebsk, Russia, 1909. Lives in Hartford, Connecticut.

— Compositionally I confronted myself with a square canvas which focused my gaze to the center point. I countered by drawing a vertical line through the center, creating two rectangles which I set in play against each other by means of my subject, the books. — Joseph Solman, 1944.

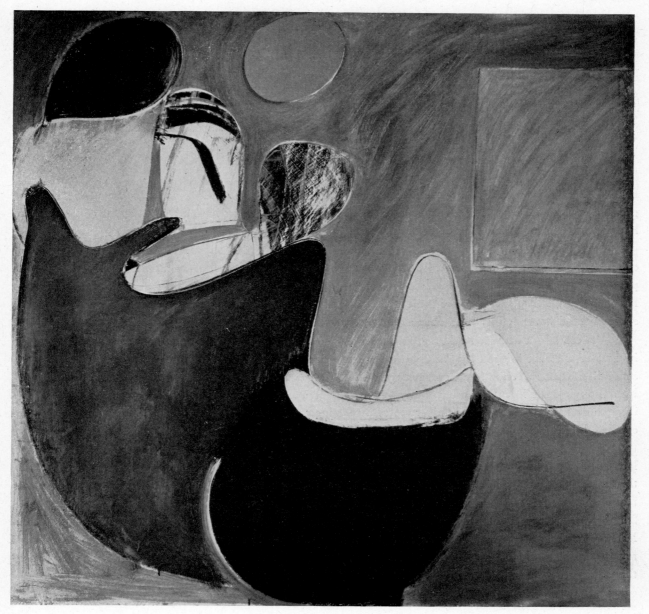

58 WILLIAM DE KOONING
THE WAVE, 1942-43, oil 48 x 48″. *Collection the Artist.* Born Rotterdam, Holland, 1904. Lives
in New York.

4 AMERICAN SURREALIST PAINTERS

IF AMERICA has its organization, its specialization, its worship of mechanics, its devotion to clean, precise, efficient machine appurtenances, it also has their counterpart in the ramifications of life within its machine-age superstructure of fantasy.

Mass production, the boon and the blight of modern civilization, the hallmark of contemporary culture, is the fabulous progenitor of other equally astonishing phenomena: mass travel, mass spectator participation, mass entertainment, mass play. The patent medicine myth of modern advertising articulated through loudspeakers on the radio and in the movies, selling coming attractions, leisure and pleasure, spreads the dreams of insomnia over everyday life.

These and a hundred other aspects of daily experience accepted in the natural course of things by masses who are swayed by the spell of contemporary trends, are surrealist in essence. For all that, surrealist art in America is comparatively young. Yet its infectious gaiety and sardonic seriousness, its lush though dark beauty, have rapidly gained for it a place in the sun. In contrast with the severe intellectuality and almost puritanical restraint of much abstraction, which many temperaments find too constricting, it has a wide and instantaneous appeal.

This quick acceptance has occurred without benefit of the organized group concentration that launched surrealist activity in Paris, London and other international centers. In New York, and dispersed throughout the country, an increasing number of practicing artists, including many new young painters, make up its voluntary rank and file. While in their earlier phases the work of some of them introduced fragmentary surrealist elements, time, experience, and the presence here of artists in exile, among them leaders of the movement, have brought about a clearer comprehension of the expansive nature of surrealist method and the implications of the "marvelous" that constitute the surrealist point of view. Then there are painters, who, like Klee, make pictures that are ostensibly surrealist in spirit, although this coincides in no way with the intention of the artist. On the other hand a painter is not surrealist merely by choice. "It cannot be too strongly emphasized," writes Julien Levy, "that whereas surrealism is fantastic, all fantasy is not surrealist, whereas surrealism uses symbols, all symbolism is not surrealist, whereas surrealism often is profoundly disturbing, all that is shocking is not *ipso facto* surrealist."

Because the movement began so recently in America, a historical survey of surrealist activity here is necessarily brief. Julien Levy in his gallery and in his imaginative book *Surrealism*, has consistently disseminated the salient features of surrealist aims, and the activities of this gallery have stimulated many of the younger artists and helped to clarify for them the issues involved. The first examples of art by members of the official surrealist group to reach the New York public were shown at his Madison Avenue gallery in 1932 — works by Man Ray, Dali, Ernst, Tanguy and Chirico, among others. The American Cornell's objects of fantasy and play were later included, and after the gallery moved to 57th Street, Matta, Paalen, Magritte and several others were added to the list of exhibitors. Julien Levy's catalogues, often brochures in surrealist form, set the mood and enliven the shows.

Other galleries hospitable to European surrealists have been: Valentine, Matisse, Becker, Buchholz; and those that later exhibited Americans who had been gravitating toward this viewpoint are Willard, Pinacotheca, the Artists' Gallery, Norlyst, Durlacher and Peggy Guggenheim's *Art of This Century*. This museum, in whose Kiesler-designed experimental galleries pictures are either hung or suspended or peep-boxed, has been a particularly active center, since its inception in 1942, for both abstract and surrealist art. Its permanent collection is divided between the surrealist curved-wall chamber where important international painters are installed, and the abstract room where twentieth-century leaders from cubism to today are assembled. Supplementing these are changing exhibits in which new faces are constantly seen.

To the Wadsworth Athenaeum at Hartford goes the distinction of having held in 1931 the first exclusively surrealist exhibition in America, though all examples were European. A more comprehensive exhibition took place in 1936 when the Museum of Modern Art assembled a historic continuity of *Fantastic Art, Dada, Surrealism*, which subsequently, on a reduced scale, traveled to other museums. This time a few Americans were included.

The artists presented in this chapter are so grouped not because they are alike outwardly or derive from the same sources, but because consciously or otherwise they have the surrealist approach. Their pictorial form may be the result of pure psychic automatism, and in this case images may or may not appear *a posteriori*, but in general their works derive from *a priori* images, each freely developed, at times quite spontaneously and at others controlled and directed. Techniques of creative release graduate from automatism through compulsion, spontaneity, free association, to the illusion of *trompe-l'oeil*, and include elements of chance, all of which have been briefly discussed in Chapter I.

The various artists who lean somewhat in a given direction fall naturally into groups. There are those who, attracted to the linear fantasy of Klee, still retain the stamp of their varied personalities. Though they, too, disclaim any tie with surrealist ideology, the tenor of their work is just as surrealist. The moonlight fantasies of MacIver and Graves, two of the painters in this group, have related themes. In MacIver's legend (59), the moon metaphorically reaches through the window and embraces the bed, a heavenly bed which like midnight skies is strewn with stars. Graves' moonbeams in *Bird in Moonlight* (60) are so tangible that they almost submerge the bird, literally burying it in light. Both pictures are poetic and possessed.

The village furnishes the motif for others of the same group. Knee's *Snowbound* (65) is like a gay flashback through frost and time to a gallery of pictures and impressions aroused by revery. The hieroglyphics of structure in Rosenborg's *Village* (61), stark, luminous, heavily pigmented, are the strange remnants of a familiar civilization. Gatch's *Light Snow and High Water* (62) is a mirage in which properties of land, sea and air are interchangeable. The boat-shaped segments of land in this panoramic view of an inundated area float in space like ships of the air.

Tobey's *Threading Light* (66) is a parable of good and evil in which the free calligraphy of white writing circumscribes the religious iconography. Opposing planes of ethical imagery are established by two focal points, a light area above (plane of good) and a dark area below (plane of evil).

Hillsmith's *Flower Garden* (67) and Baziotes' *The Balcony* (68) are both line and tone poems, one corresponding to a cross-section of cell division in process of growth and the other a shimmering reflection through heat waves of tropical light. Baziotes is the only one of the preceding group of painters of linear fantasy directly allied with surrealism.

Mrs. Janet Sobel, a self-taught painter, a primitive, has an abundant personal vocabulary of images which flow from her brush with great spontaneity. *Music* (64) was painted while the artist was under the emotional impact of Shostakovitch's Seventh Symphony. The method here is so free that it approaches pure automatism.

Another self-taught painter is Hirshfield, designated by Breton as "the first great mediumistic painter." The picture *Girl with Pigeons* (63) is converted by virtue of the intense compulsion of the psychological drive into a new reality in which the objects become symbols interpreting the nature of this drive.

In 1913 Duchamp exploited the element of chance and this has since been a key factor in dada-surrealist creative activity. The fortuitous use of the decalcomania technique by Max Ernst throughout dadaism and surrealism is well known. In America Margo and Jimmy Ernst continue this tradition, each in his own way. Margo's *Matrix of an Unfathomable World* (69) is a subterranean fantasy which paraphrases in visual terms the graphic description of the role of surrealism by Hugnet: "Little by little in these fathomless depths, penetrated by the light of surrealism, new strata of reality come into being." Jimmy Ernst, talented son of Max, and the youngest artist represented, improvised from chance his fantastic floating ectoplasm, entitled *Echo-Plasm* (70), and endows it with the suggestion of an extra dimension, the macabre suggestion of remote sound emanating from intangible substance. Racz (71), also working with chance, transports the observer to an underseas planet, and Kamrowski (72) converts accident into an anatomical electric light system — a magical object.

Three-dimensional objects hold an important place in surrealist procedure but they are essentially sculpture, although wall objects come within this survey. Cornell is perhaps the most consistent surrealist personality in America, for to him, especially, surrealism is more than an esthetic — it is a way of life. His "toys for adults" are at once perplexing enigmas and marvels of delight, and his *de Medici Slot Machine* (73) is a Renaissance game in which the characters unpredictably appear, disappear and reappear.

Reverting again to painting: Dorothea Tanning travels the paths of verisimilitude, symbolism and double imagery in her frank psychological self-portrait *Birthday* (74). The skirt is festooned with driftwood resembling *objets trouvés*, the branches of which metamorphose into dozens of erotic figures interspersed with other "*objets trouvés*." Before doors ajar, she stands with open face and open bodice, unperturbed in the presence of a spread-winged chimera of wide-eyed terrifying mien — all variations on the open motif.

The following three paintings go far afield. In the transfixed terrestrial space of Model's *Oceanside* (81), a pervasive loneliness is evoked through shock of color-surprise and unexpected spatial juxtapositions, immediate and remote. Properties of metaphysics are also present in Bayer's interplanetary *Communications in Space* (77) which though abstract, is animated by forms and structure of natural elements; while the carnivorous vegetation in a state of perpetual suspension creates a boundless netherworld in Kelly's *Departure through the Umbrellas* (75).*

Hallucinatory painting, one of the rich surrealist sources, is represented here by four widely diverse examples, ranging from the poetic fantasy of Cristofanetti's *The Comet* (76), a Lorelei of the skies, to the almost psychopathic frenzy of Lorenz' social document *Pink Slip* (82) with its poignant and tragic feeling of deep sinking, of cataclysm. Somewhere between these two are the obsessive painting, *She-Wolf* (80) by Pollock, the product of furious slashing of pigment, and Quirt's *The Crucified* (79), made by the compulsive weaving of multicolored patterns.

Heatage (87) by Hare, the most original of the younger sculptors, is a "chemical painting" which suggests the mysterious slow-motion processes of nature.

Myth and fable, which have supplied endless themes, are a treasure-trove for images. Rothko and Gottlieb have plumbed these sources. Both artists are known as abstract painters, but they are represented here, the one by *The Omen of the Eagle* (83), the other by *Pictograph #4* (84), because surrealist overtones prevail.

* Artists often choose arbitrary titles for their work, although seemingly arbitrary titles sometimes throw light upon psychological or other factors in the painting.

Gorky, long an abstract painter, has always worked from nature. Only recently, since his style has become more free and his approach more intuitive, has his work become surrealist rather than abstract. *The Liver Is the Coxcomb* (85) contains a rich basis of sensibility reached by a high degree of freedom quite like automatism. Hayter, too, has painted abstraction. Subjective processes place his work of recent years, despite its seemingly abstract character, in the surrealist category. In London he was a member of the surrealist group. The characters in *Ophelia* (86) are contrived with automatic line.

Though abstraction and surrealism are considered countermovements in twentieth-century painting, there is in certain painters a fusion of elements from each. American painters particularly have a strong inclination to develop interchanging ideas which may fit into either tradition, though there are purists in both categories who adhere to basic premises and moreover insist that it is impossible to do otherwise. Apparently the schism between the factions is not as insurmountable as their members believe. That abstract painters are able to bridge the gap to surrealism is indicated in the work of the four artists last mentioned. It is also true that the opposite takes place. Motherwell, formerly a member of the surrealist circle, still retains surrealist ideas while approaching pure abstraction. Artists who embrace both directions have for a precedent the work of Picasso.

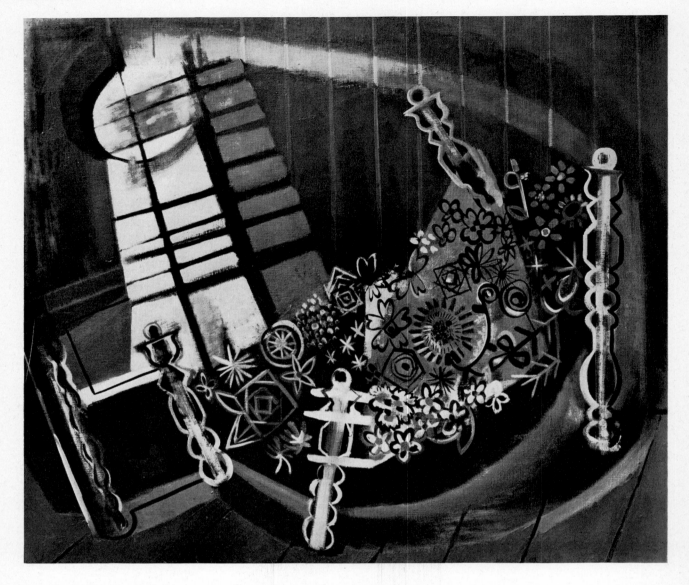

59 LOREN MACIVER
MOONLIGHT, 1940, oil 32 x 36″. *Collection Dr. John Dewey. Born New York, 1909. Lives*
in New York.

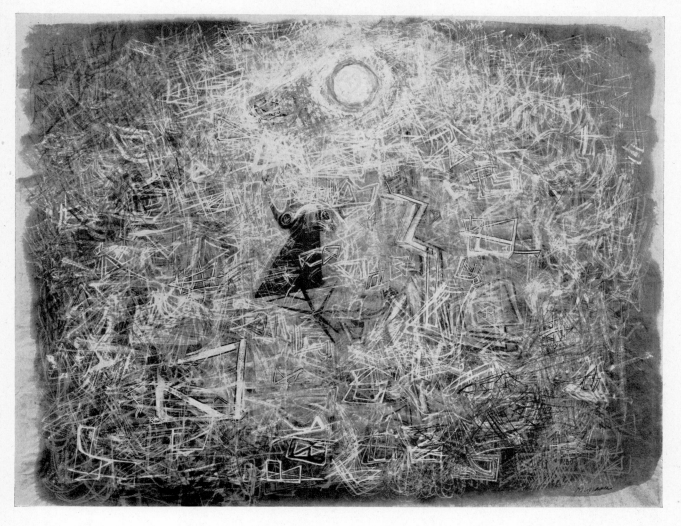

60 MORRIS GRAVES
BIRD IN MOONLIGHT, c. 1939, gouache 25 x 30¼". *Collection Mrs. Nancy Wilson Ross.* Born Fox Valley, Oregon, 1910. Lives near Seattle.

— When *Bird in Moonlight* was painted, the Tobey-like writing and geometric forms in which the bird is submerged was a conscious attempt to poetically help materialize a molecular content of moonlight, impregnated with messages. The bird was given two heads because of its divided emotion: ecstatic song or silence. They are a symbol of that frightful and unexplained linking of joy and despair. — **Morris Graves, 1944.**

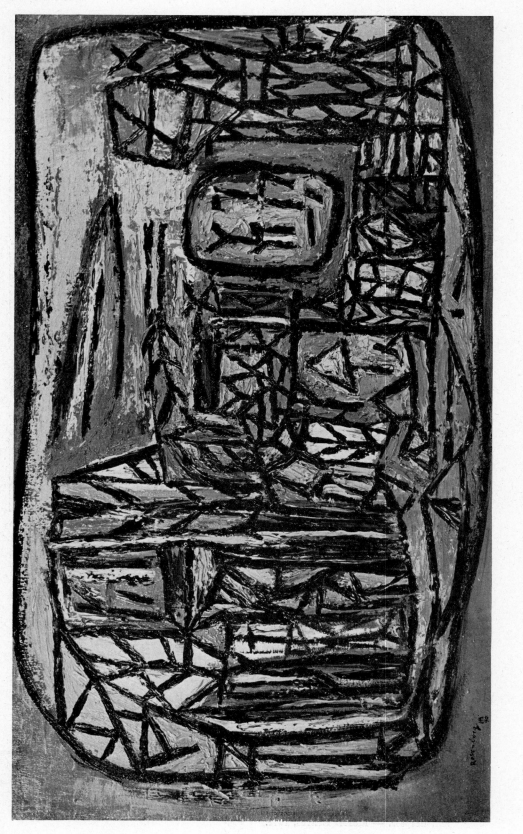

61 RALPH ROSENBORG

VILLAGE, 1940, oil 18 x 31". *Collection Marion Willard.* Born New York, 1910. Lives in New York.

— Painting is intensification of intuitive introspective instinct-effort. If my work is organic to myself, it is inevitable. This painting, *Village*, of 1940, is not an epic or dramatic classification of a village seen, but rather a rhapsodic village felt, honest and consistent with my inner tension of 1940. If the observer can *see* or *listen to* or *feel* it, or be receptive to it, then that is all the tension-pure painter or instinct-pure composer can ask. — Ralph Rosenborg, 1942.

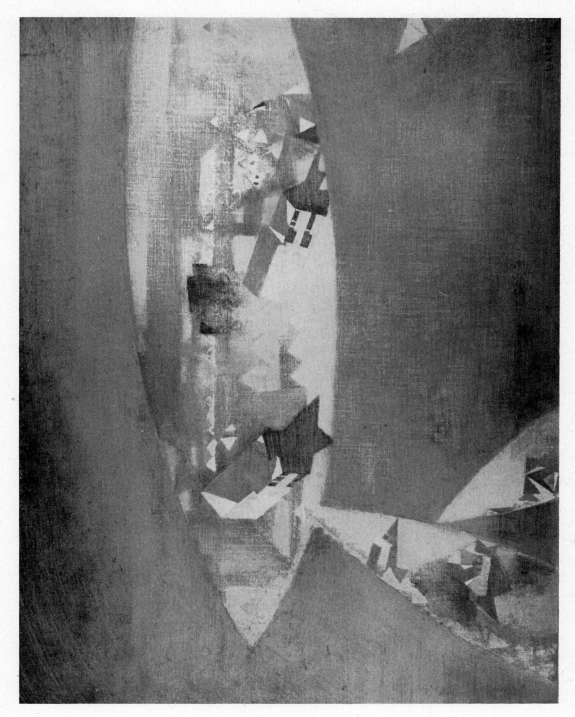

62 LEE GATCH
LIGHT SNOW AND HIGH WATER, 1942, oil 18 x 24″.
Collection Willard Gallery. Born Baltimore, 1902. Lives in
Lambertsville, New Jersey.

— *Light Snow and High Water* represents three isolated areas of inundation, a flood without
drama. — Lee Gatch, 1944.

63 MORRIS HIRSHFIELD
GIRL WITH PIGEONS, 1942, oil 30 x 40". *Private Collection.* Born Russia-Poland, 1872. Lives in Brooklyn, N. Y.

— I concentrate my mind on the work I do. You do the best you can but constantly make changes. The whole beauty in painting is contrast, the all important thing in painting I consider exactness. Colorings must be selected to suit the occasion. A brush must be so fine that it can write like a pen. I sharpen my brushes. I have no favorite subjects. I paint from my mind. — Morris Hirshfield, 1944.

64 JANET SOBEL
MUSIC, 1944, oil 24 x 17½". *Collection the Artist.* Born Russia, 1894. Lives in Brooklyn, N. Y.

— *Music* is my impression of the music of Shostakovitch created in a world torn by war and bloodshed. Shostakovitch has captured the power of the Russian people and by his music has given them strength. His music has so stimulated me, and I have tried to present these feelings in my picture. — Janet Sobel, 1944.

65 GINA KNEE
SNOWBOUND, 1941, water-color
26 x 21″. *Collection Willard Gallery.*
Born Marietta, Ohio, 1898. Lives in
Los Angeles.

— The representational parts of this painting are more about a state of mind than about a winter scene. The ladies sit behind glass windows looking placidly into a frozen world of tangled objects. That the ladies go on sitting there, snowbound, is perhaps an objective statement, but I hope their suspended isolation makes more real the inner life of their surroundings, the outer world. — Gina Knee, 1942.

66 MARK TOBEY
THREADING LIGHT, 1942, egg
tempera 29 x 19″. *Collection Museum
of Modern Art.* Born Centerville, Wisconsin, 1890. Lives in Seattle.

— White lines in movement symbolize light as a unifying idea which flows through the compartmented units of life, bringing a dynamic to men's minds ever expanding their energies toward a larger relativity. — Mark Tobey, 1943.

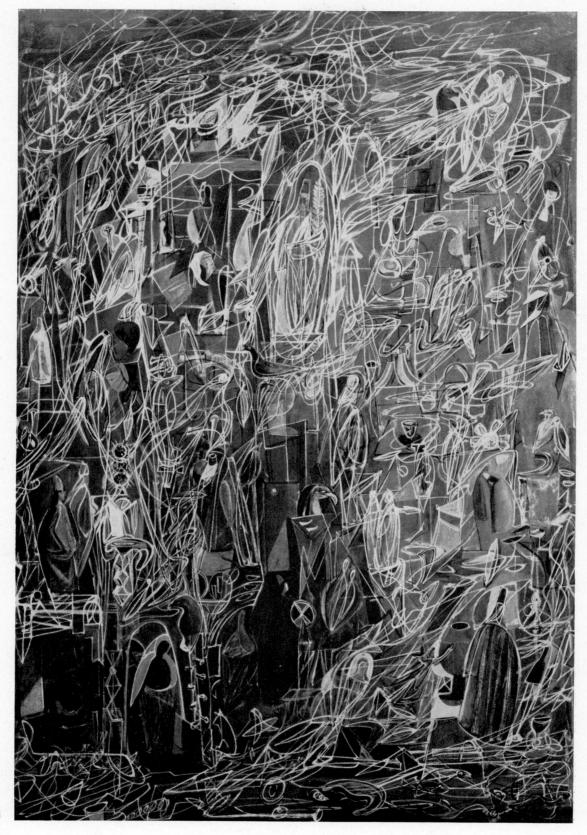

66

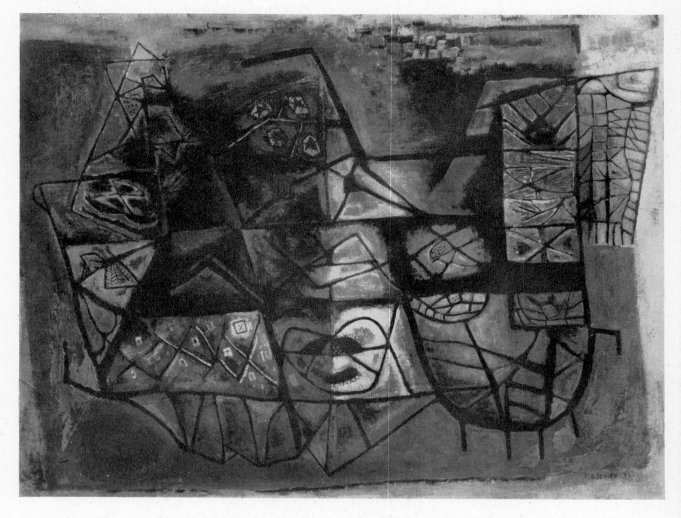

67 FANNIE HILLSMITH
FLOWER GARDEN, 1943, tempera 30¾ x 39¾". *Collection Norlyst Gallery*. Born Boston, 1911. Lives in Jaffrey, N. H.

— I endeavor to find a personal way to express in painting the basic qualities of nature. I try to combine the structural with the intimate and to secure simplicity by using few colors and shapes, to acquire variation by using these in diverse ways throughout the canvas. — Fannie Hillsmith, 1943.

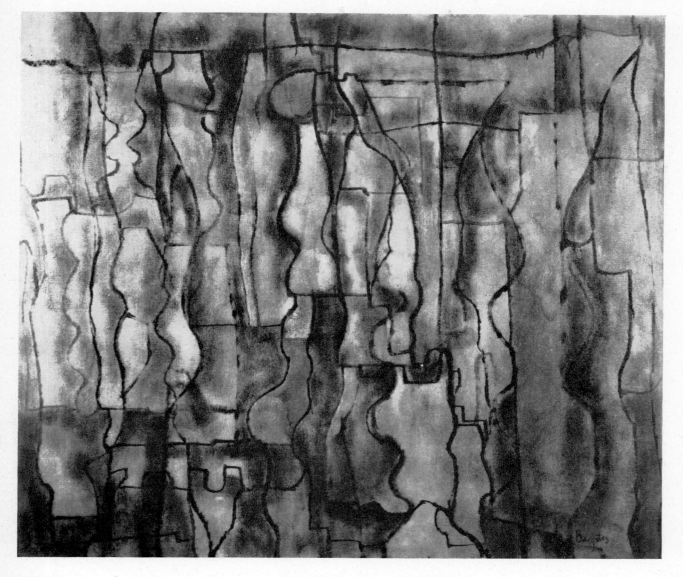

68 WILLIAM BAZIOTES
THE BALCONY, 1944, oil 36 x 42".
Collection the Artist. Born Pittsburgh, Pennsylvania, 1911. Lives in New York.

— There is always a subject in my mind that is more important than anything else. Sometimes I am aware of it, sometimes not. I keep working on my canvas until I think it is finished. The subject matter may be revealed to me in the middle of the work, or I may not recognize it until a long time afterward. — William Baziotes, 1944.

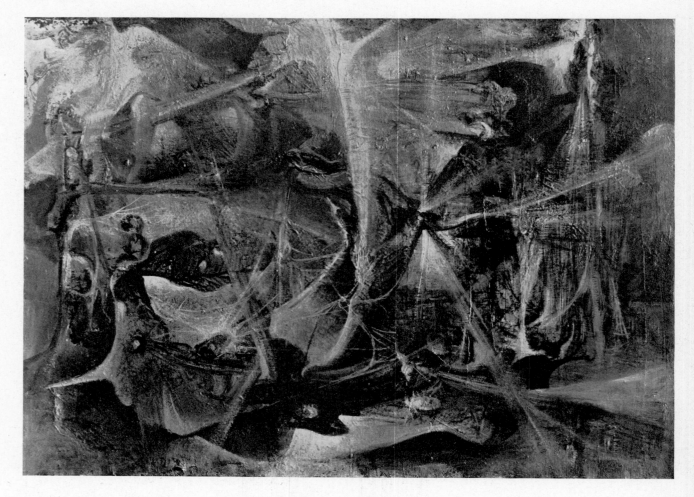

69 BORIS MARGO
MATRIX OF AN UNFATHOMABLE WORLD, 1942,
oil 25 x 30″. *Collection Norlyst Gallery.* Born Russia, 1902.
Lives in New York.

— This painting is a pure fantasy of shapes and images which undergo metamorphoses controlled by *forces* of light. In this, as in all my work, I had no desire to achieve absolute clarity. It changed according to my state of mind as I worked. It will change according to the mood of those who look at it. — Boris Margo, 1942.

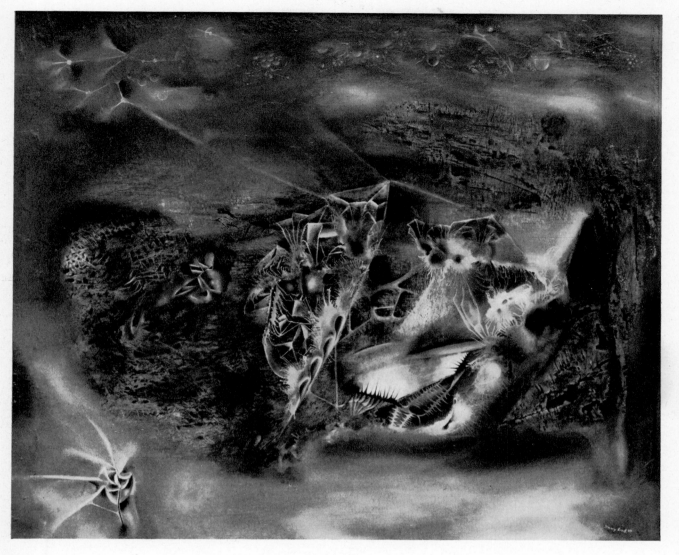

70 JIMMY ERNST
ECHO-PLASM, 1944, oil 27 x 32″. *Collection Norlyst Gallery.*
Born in Cologne, Germany, 1920. Lives in New York.

— Sounds and voices, bearing witness to multi-million epochs are encased within the crevices of Echo-Plasm. A given pitch will release all sounds, re-echoing history from the thunder of the falling walls of Jericho to the wail of Benny Goodman's swing. — Jimmy Ernst, 1944.

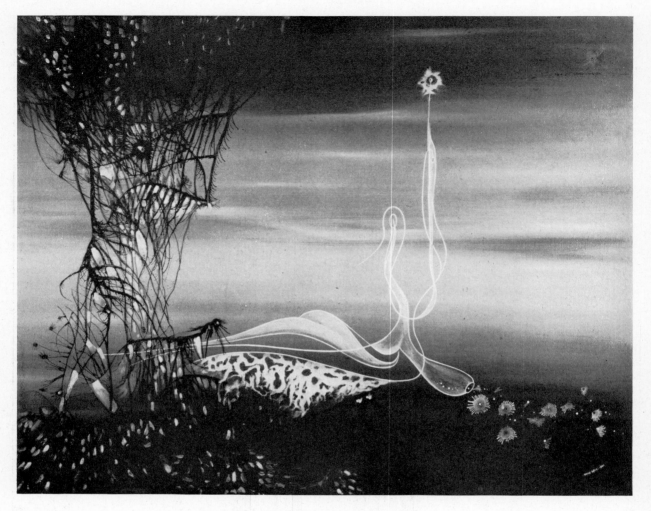

71 ANDRE RACZ
THE SWAN, 1941, oil 24 x 30". *Collection the Artist*. Born Cluj, Transylvania, 1916. Lives in New York.

— Art is the expression of the relationships between man and the universe. Today more than any other time before, a prophetic duty befalls the artist. In a gold and blood-mad society dominated by perhaps the biggest tyrant, the machine, the artist has to persist in maintaining the indispensable ties with nature . . . — André Racz, 1942.

72 GEROME KAMROWSKI
INTERNAL MOTION OF A FLUID, 1943, oil 26¼ x 13". *Collection the Artist*. Born Warren, Minnesota, 1914. Lives in St. Mary's, Georgia.

— The result of this process (building up the form) expresses itself in the formation of abstractions or concepts which are not identical with perceptual objects or happenings that conditioned their formation, but that serve as a conceptual symbolization of those aspects which were regarded as alone relevant for the purpose . . . — Gerome Kamrowski, adopted from E. W. Hobson's *The Domain of Natural Science*.

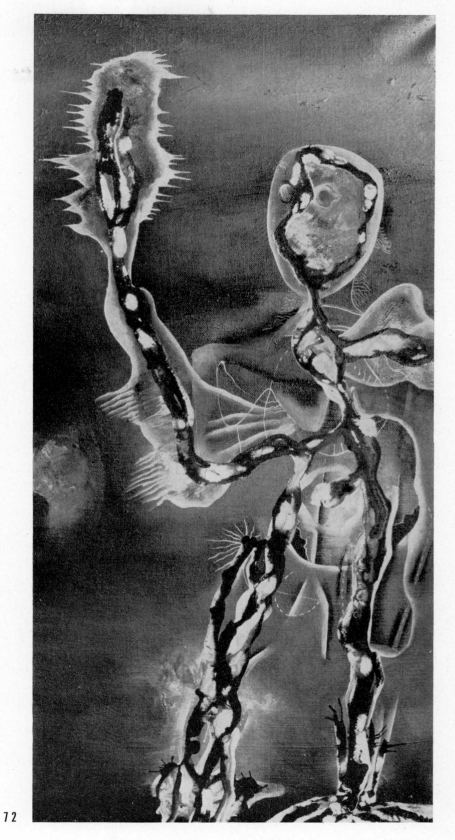

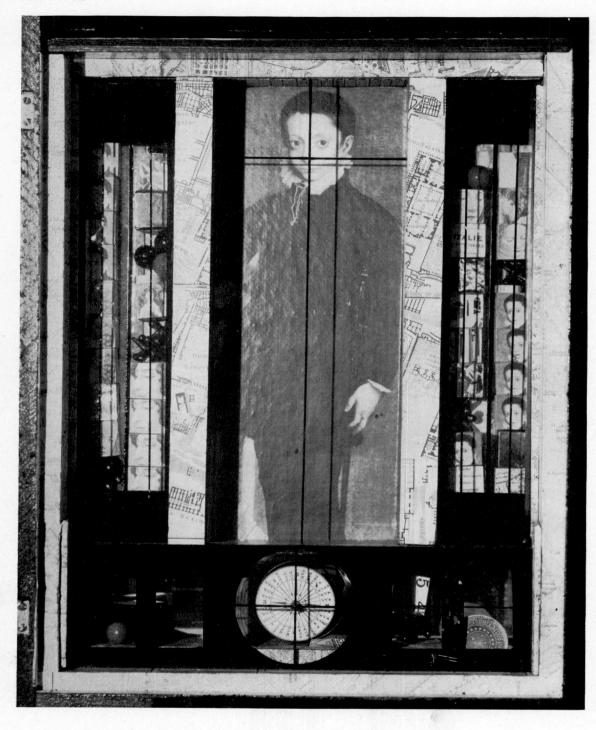

73 JOSEPH CORNELL
DE MEDICI SLOT MACHINE,
1941, wall object 15 x 11". *Collection
Mr. & Mrs. Bernard Reis.* Born Nyack,
N. Y., 1903. Lives in Flushing, N. Y.

— It is too difficult to get into words what I feel about the "objects." — Joseph
Cornell, 1944.

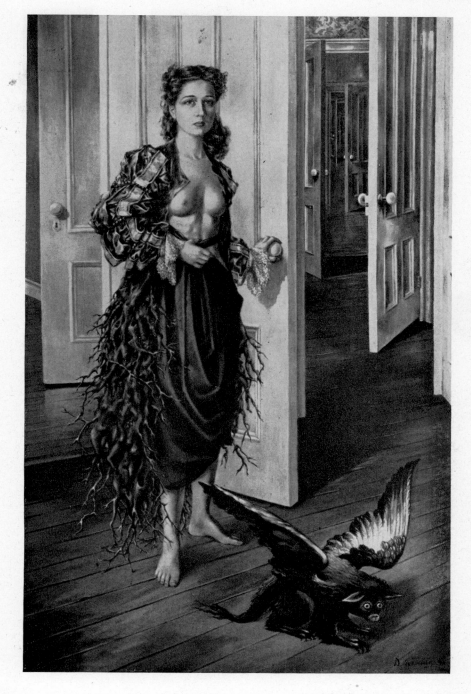

74 DOROTHEA TANNING
BIRTHDAY, 1942, oil 40 x 25". *Collection Julien Levy Gallery.* Born Galesburg, Illinois, 1913. Lives in New York.

— One way to write a secret language is to employ familiar signs, obvious and unequivocal to the human eye. For this reason I chose a brilliant fidelity to the visual object as my method in painting *Birthday*. The result is a portrait of myself, precise and unmistakable to the onlooker. But what is a portrait? Is it mystery and revelation, conscious and unconscious, poetry and madness? Is it an angel, a demon, a hero, a child-eater, a ruin, a romantic, a monster, a whore? Is it a miracle or a poison? I believe that a portrait, particularly a self-portrait, should be somehow, all of these things and many more, recorded in a secret language clad in the honesty and innocence of paint. — Dorothea Tanning, 1943.

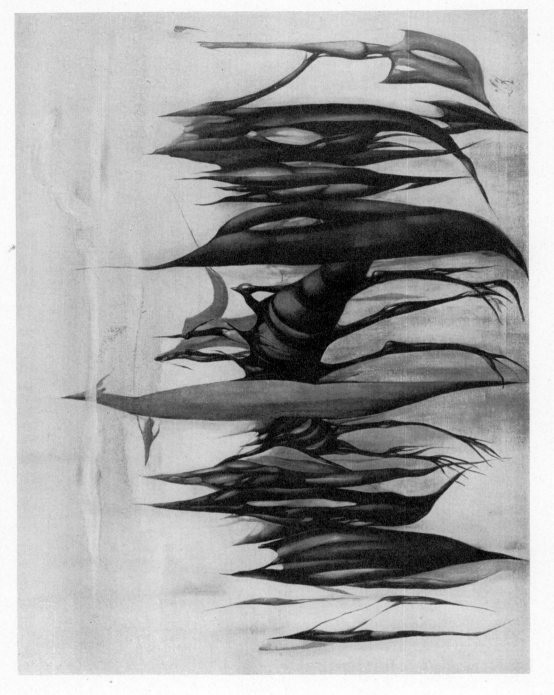

75 LEON KELLY
DEPARTURE THROUGH THE UMBRELLAS, 1944,
oil 20 x 24". *Collection Julien Levy Gallery.* Born in Philadelphia,
1901. Lives in Philadelphia.

— This picture of vegetation and insects translates a synthesis of my present psychological
reactions. I have evolved in painting a realm of events corresponding in intensities to life as it
affects me. The actors or subjects in the picture are flexible forms complying suitably to the
evolution of my painting. The umbrella shape which I have given to figures, plants, insects, has
a dramatic emotional meaning to me, The insect in the painting represents the ego. — Leon
Kelly, 1944,

76 FRANCESCO CRISTOFANETTI
THE COMET, 1942, oil 33 x 45". *Private Collection.* Born Rome, 1901. Lives in New York.

— This painting with a human figure was made during a period in which for almost two years I devoted my interest to painting moving subjects such as carriages, ships, sails, wings, the importance in the movement itself rather than in the representation. It seems to me that this feeling of movement and flight I tried to express can also be found in this painting of a human figure, as well as lighting which is generated by the central subject of the composition. — Francesco Cristofanetti, 1942.

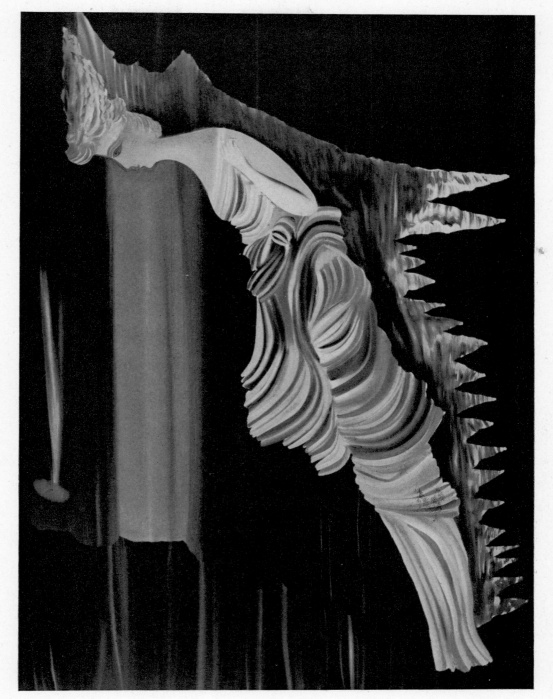

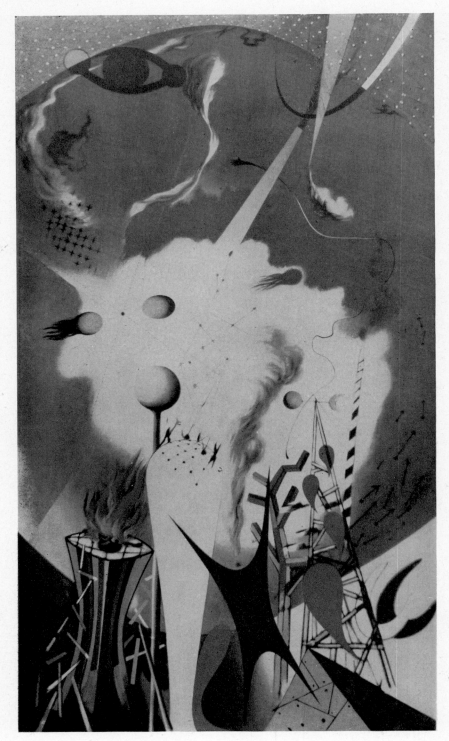

77 HERBERT BAYER
COMMUNICATIONS IN SPACE,
1941, oil 66 x 37". *Collection the Artist.*
Born Haag, Austria, 1900. Lives in New
York.

— . . . limitless space no beginning no end powerful forces seemingly undisciplined chaotic impetuous world supersensible intangible regions of relationship interaction exchanges transposition commutation flare flash blaze radiant signals turbulent untamable collision explosions . . . — Herbert Bayer, 1944.

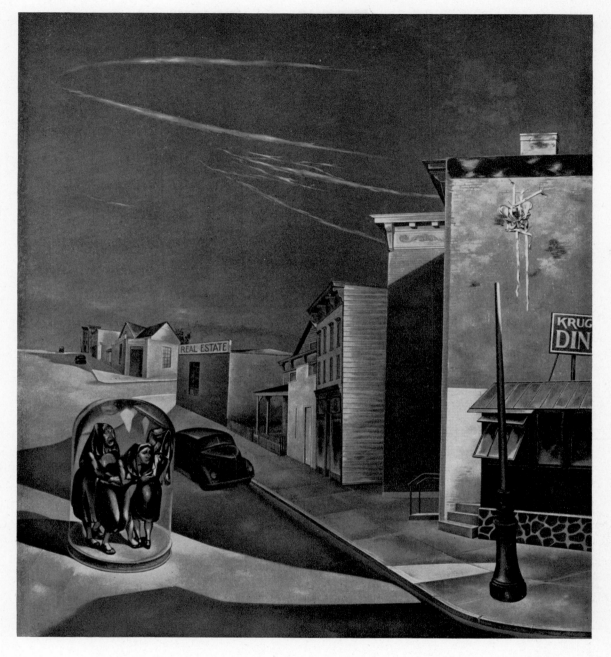

78 O. LOUIS GUGLIELMI
TERROR IN BROOKLYN, 1941,
oil 33½ x 29½". *Collection the Whit-*
ney Museum of American Art. Born
Milan, Italy, 1906. Lives in Brooklyn,
N. Y.

— The painter finds the poet. The fleeting shaft of sun in the dusk of a world;
the terror of the three pelvic beatitudes in the test tube of a bell; the street,
a reflected image of itself. A premonition of war and tragedy. — O. Louis
Guglielmi, 1942.

79 WALTER QUIRT
THE CRUCIFIED, 1943, oil 30¼ x 50". Collection Durlacher
Brothers. Born Iron River, Michigan, 1902. Lives in New York.

— The Crucified is an accurate picturization of the growth of sadism within American society,
painted without moral conclusions. — Walter Quirt, 1944.

80 JACKSON POLLOCK opposite
SHE-WOLF, 1943, oil 42¼ x 67". Collection Museum of Modern
Art. Born Cody, Wyoming, 1912. Lives in New York.

— She-Wolf came into existence because I had to paint it. Any attempt on my part to say some-
thing about it, to attempt explanation of the inexplicable, could only destroy it. — Jackson
Pollock, 1944.

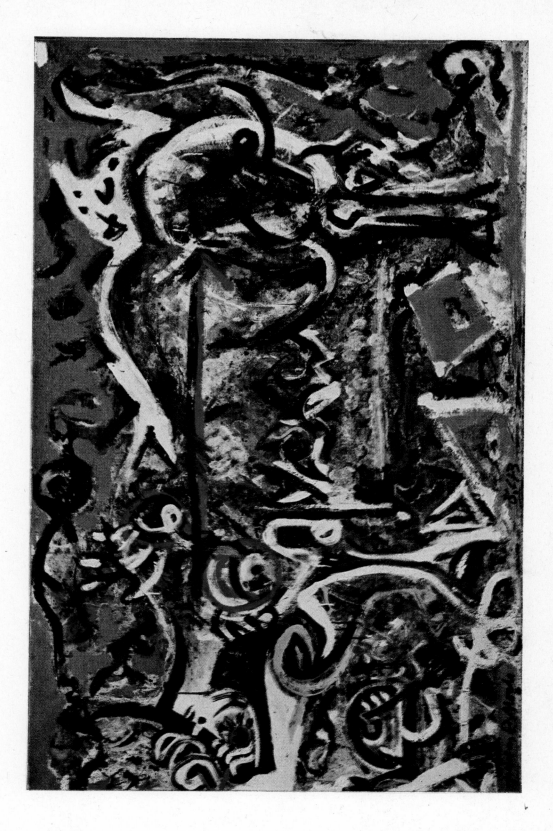

— Cubic buildings. Rolling trains. Running cars. Little spots of electric bulbs. Rectangles of popular flags. Being plastics of modern thought and elements of social needs they are guiding esthetics for my painting, the colored trigonometry of place, time and space. Away from the dead ideologies and the decadence of pompous palaces. — Evsa Model, 1944.

81 EVSA MODEL
OCEANSIDE, 1943, oil 42½ x 65". *Collection Mr. M. Martin Janis.* Born Siberia, 1901. Lives in New York.

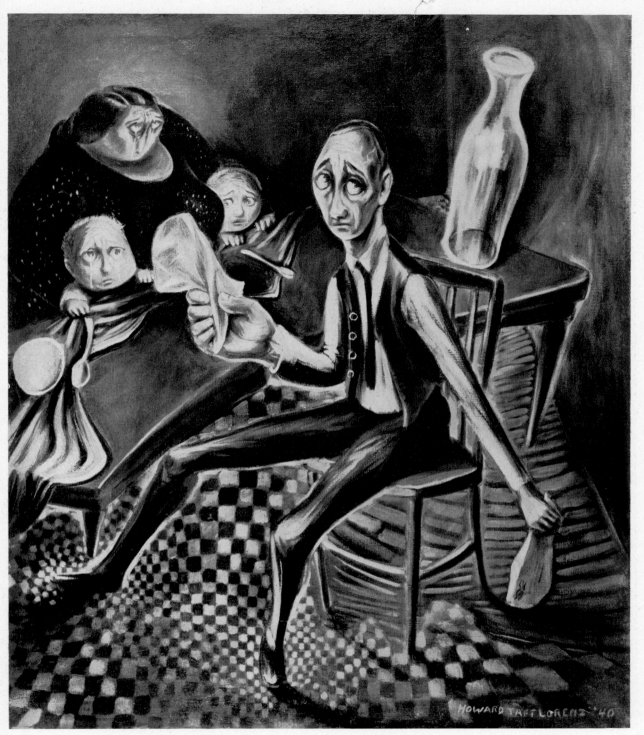

82 HOWARD TAFT LORENZ
PINK SLIP, 1940, oil 36 x 30″. *W.P.A. Art Program.* Lives near Los Angeles.

83 MARK ROTHKO
THE OMEN OF THE EAGLE,
1942, oil 25½ x 17½". *Collection the
Artist.* Born Dvinsk, Russia, 1903. Lives
in New York.

— The theme here is derived from the Agamemnon Trilogy of Aeschylus. The
picture deals not with the particular anecdote, but rather with the Spirit of
Myth, which is generic to all myths at all times. It involves a pantheism in which
man, bird, beast and tree — the known as well as the knowable — merge into
a single tragic idea. — Mark Rothko, 1943.

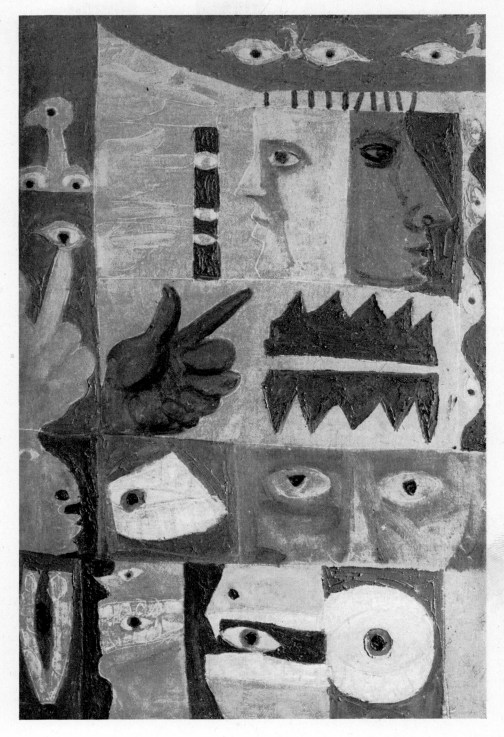

84 ADOLPH GOTTLIEB
PICTOGRAPH #4, 1943, oil 34 x
23". *Collection The Artists' Gallery.*
Born New York, 1903. Lives in Brook-
lyn, N. Y.

— I disinterred some relics from the secret crypt of Melpomene to unite them
through the pictograph, which has its own internal logic. Like those early
painters, who placed their images on the grounds of rectangular compartments,
I juxtaposed my pictographic images, each self-contained within the painter's
rectangle, to be ultimately fused within the mind of the beholder. — Adolph
Gottlieb, 1944.

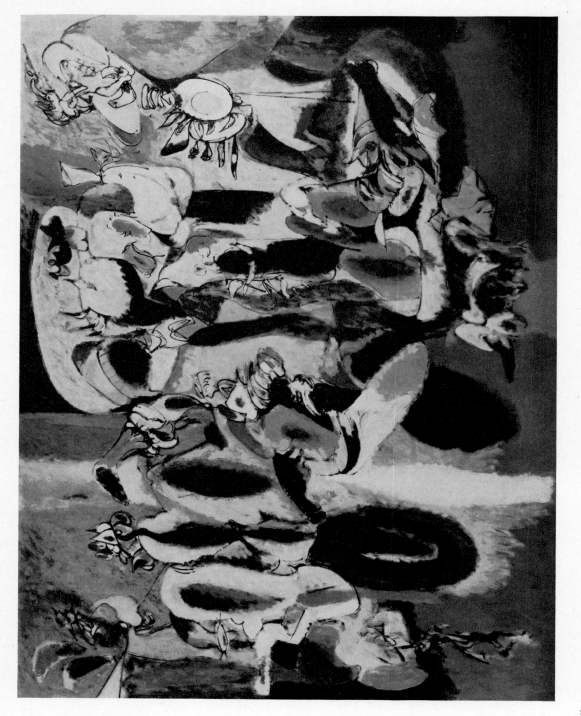

85 ARSHILE GORKY
THE LIVER IS THE COXCOMB, 1944, oil 66 x 96".
Collection the Artist. Born Tiflis, Russia, 1904. Lives in New York.

— The song of a cardinal, liver, mirrors that have not caught reflection, the aggressively heraldic branches, the saliva of the hungry man whose face is painted with white chalk. — A. Gorky, 1944.

86 STANLEY WILLIAM HAYTER
OPHELIA, 1936, oil 39 x 57". *Collection the Artist.* Born London, 1901. Lives in New York.

— *Ophelia* represents lines of flow in water, intense light, floating flower, insect, fragments of human form — held as with surface tensions of liquid. Subsequently I have traced the motive to obsession since age of 8 with *Ophelia* painting by Millais, in which the wench is floating in a sort of green "marinade," flowers are like scum. Perhaps precision of these Pre-Raphaelites fixed their attention on detail as seers fix upon a crystal in auto-hypnosis? — S. William Hayter, 1942.

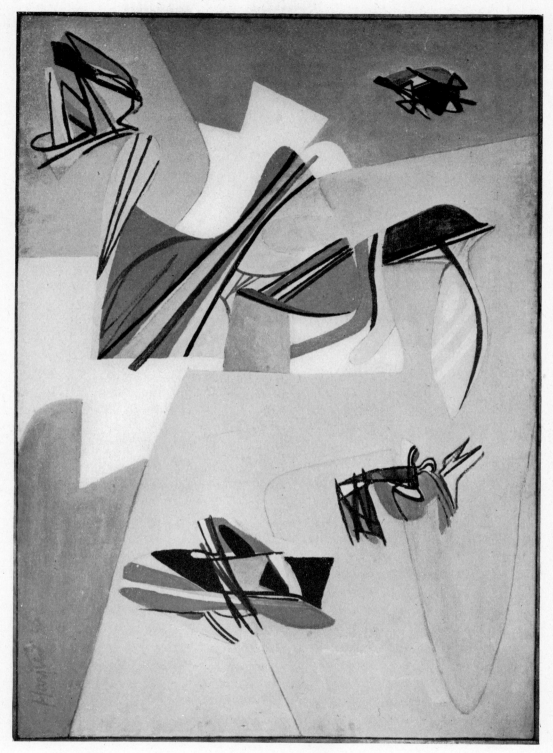

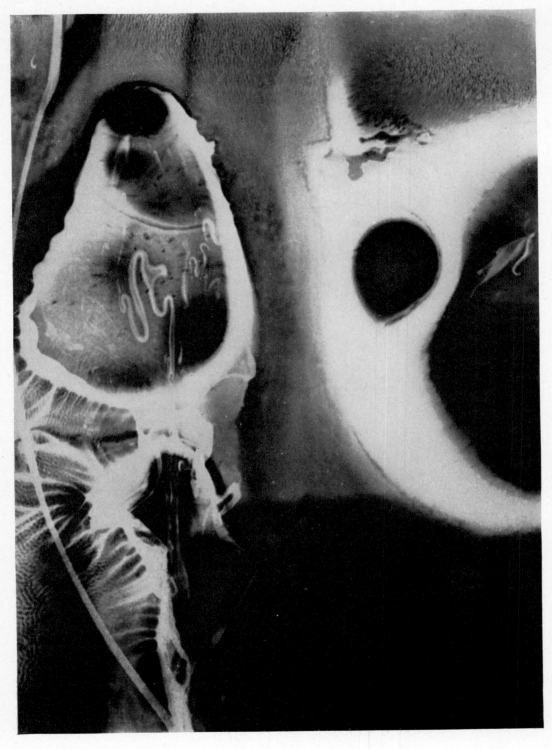

87 DAVID HARE
HEATAGE, 1944, "chemical paint-
ing" 13 x 9″. *Collection the Artist.*
Born New York, 1917. Lives in New
York.

— These forms are created by the action of one element upon another — an attempt to show graphically the antagonisms of matter. — David Hare, 1944.

5 AMERICAN PAINTINGS BY ARTISTS IN EXILE

LONG BEFORE the rise of the Nazis in Germany, twentieth-century European artists were attracted to our shores. Invited by the Carnegie International through its system whereby prize winners of one year serve as jurors the year following, Matisse and others had come for this purpose. Léger and Hélion, both imaginatively responsive to the American genius for mechanization, found here a world which was their natural milieu. But the migration *en masse* took place after 1934, when first the progressive artists no longer tolerated in Germany, and then others, dislodged by the war from their homes in France and other countries, came here to live. Painters who have developed individual means with which to penetrate the innate culture of the contemporary world, men of widely different native backgrounds but of international focus in their esthetic points of view, they have now transplanted their talents to America. The interwar period abroad had not been too distinguished, some artists having lost their earlier esthetic vitality. The new environment has had a salutary effect upon them, for the stature of their work shows a new vigor. And, if inspired by their new environment, they have in turn inspired our artists anew. In an atmosphere where creative artists hold tenaciously to their highest aims, more rigid standards inevitably prevail and more important accomplishments inevitably result.

Mondrian was one of the few painters whose work did not suffer because of the first World War. His artistic growth was constant. Continuing in his appointed direction after his arrival here, he added complexity and fresh color distribution which gave new vibrance to his work. Despite the classic form of Mondrian's style, he was a compulsive painter, who, unlike others, developed a highly intellectualized rationalization of insistent inner drives. One would suspect that his eyes had been trained to detect as do delicate instruments, the slightest variation in the equilibrium "of unequal but equivalent oppositions." But his method was essentially that of trial and error, in which he constantly manipulated line to attain the precision he sought, sometimes working as long as a year on a single canvas. In his American pictures colored lines supplanted the familiar black ones and in his final two works these lines were divided into space intervals of different colors. Mondrian, for years an appreciator of jazz rhythms and in New York a devotee of boogie woogie, felt he had created corresponding mood and rhythm in these last pictures.

After three years' residence here, his death in January 1944, at the age of 72, came at a time when he was at the height of his plastic powers, having entered a compelling phase which he himself termed a "new period." The direction this was to take was already indicated on his studio walls where he had arranged red, blue, and yellow rectangular color areas of cardboard. Hundreds of pinholes were evidence of the minute changes that were necessary in order for him to gain the desired equilibrium. Further, Mondrian pointed out the "meatier" surface attained and the various gradations of white he had used in his *Victory Boogie Woogie* (88). This together with the fact that he had reverted again to gray would indicate that Mondrian had departed from his most austere concepts.

Though, on his first visits, Léger was captivated with America, his work did not reflect this until he came here to live. Now its entire character and spirit have stepped up, and today he is painting pictures with

more zest, power and originality than he has shown in many years. As an artist who visualizes the spirit of an epoch rather than the literal aspect of a given locale, his affinity for the esthetic of machine-America one would suppose should have affected his work on previous visits. That this did not happen may be due to the fact that he is no longer a visitor, and has therefore made the necesary mental transition to permanent residence.

The components of contrast and dynamism, properties of his early cubist period, are again in evidence today. He is now applying them to his study of the human body in space. *Les Plongeurs Circulaires* (89) is a two-dimensional composition in which powerful line-forms move across massive color-forms. The picture has no specified base but pivots on a central axis. Since it never appears to be inverted but can be properly viewed from any position, it might be an admirable solution of the intricate problem of ceiling painting. Léger has recently done a series on the theme of the *plongeurs*, impressive in their unending variations.

Because of long established residence in America, exiles such as Moholy-Nagy and Albers have been included with the abstract painters in the American chapter. However, Ozenfant, who has been here almost equally as long, is placed in this chapter because of his long affiliation with the School of Paris, as the innovator with Jeanneret, of purism, back in 1918. Ozenfant's American paintings, immaculate of surface and low-keyed in color, carry on his original principles, but have changed with his reaction to his new environment. In his strange, dramatic landscapes of Arizona, almost pure abstraction, he has caught the spirit of the corroded ancient monuments of nature which proved so elusive to the many artists who have tried to capture it through more representational means (96).

The artists that follow are, with the exception of Chagall, members of the surrealist group. Most of them came from France between 1939 and 1941 and have been active here in their chosen field.

Chagall's paintings were described by Apollinaire as possessing "the supernatural spirit," but he has always worked independently of any movement. Chagall paints Russian folklore in hallucinatory images which defy at will the laws of gravity. In America a modified fantasy replaces the illusory phantasm of his earlier work. *A ma Femme* (92) is now in its third and presumably final state, having been "finished" twice before. The three stages have been photographed, making a revealing document of the change in the artist's attitude toward a subject over a period of eleven years.

André Breton, the versatile leader of the surrealist movement and formulator of the initial and the *Second Surrealist Manifesto*, retains his leadership today. The history of his activities is long and imposing, ranging from participation in early anarchic dada through every surrealist manifestation including games, collective drawing, semi-hypnotic states and other forms of experimentation, to the present, when he is on the threshold of a third manifesto. As active here as abroad, Breton is an editor of and a contributor to *VVV*, official surrealist magazine; with Duchamp he organized the surrealist exhibit held in 1942 at the Coordinating Council of French Relief Societies, Inc., editing the catalogue titled *First Surrealist Papers*; he is engaged in daily French language short wave broadcasts to the Continent for the Office of War Information; encourages new painters and crowds his hours further by creating works himself. His special form is the surrealist object, which surrealists regard as a particularly authentic expression of subjective activity — contemporary fetishes of the inner life. Previously he made "ghost objects"; now his works are "blendings of intimate writing with visual representation," termed *poème-objets* which, through symbolism and metaphor, sometimes seem to be psychological self-portraits, sometimes self-portraits through historical and other references.

Ernst, after several months in concentration camps in France, succeeded in obtaining his release and arrived in America in June, 1941. As a leader in dada-surrealist groups, his activities are well known. In his American pictures, as in the past, he continues to invent new techniques with which he creates the proper-

ties of enigma that inevitably fill his work. The chance, decalcomania-like effects that he obtained abroad and that still occupy his interest are made by compressing materials against pigment, producing deep rich undulations, as in crushed velvets. Forms are created by suggestion, and in the process of development they are metamorphosed through free association, to emerge eventually as the completed picture. Ernst, essentially intuitive, clothes his fantasy in the symbols and poetry of the unconscious.

He has recently invented a new method of chance — oscillation — and in this technique has painted several large gyrating compositions. They are produced by means of color flowing freely from a swinging container operated with a long cord by the artist. Ernst in several recent works has combined techniques as well as images from many periods. These are compartmentalized by horizontal and vertical lines which divide them into rectangular segments somewhat resembling the spatial order of Mondrian. *Night and Day* (94), painted previously, anticipated this trend. One of these pictures, *Vox Angelica*, is an autobiographical account in episodes of dream and of reality, of his peregrinations from one country to another.

Tanguy's is a domain in which the spun mythology of his dreams is set apart and beyond man's intervention by an invisible airtight aperture which allows neither entrance nor egress. In the airless calm of his otherworld spaces, the sculptured personages are suspended above or touch the floor of the horizonless atmosphere. Independent of the visage of accustomed reality, they live their own existence, governed by laws of time, space and gravity peculiar to themselves. Tanguy, long a member of the surrealist group, began his private tales of wonder in 1927. In America, unwilling to change, he has on the contrary brought his strange creatures into closer perspective (97).

In the early surrealist days, Masson was one of the ablest exponents of automatism and perhaps above all others carried this method to distant frontiers. It is still an important part of his technique. On the other hand, his keen and inquiring intellect has investigated the traditions of art and science, bringing from one a seasoned approach and from the other microscopic natural phenomena. Like Léger, Masson has had a very productive career in America. His paintings approach in manual spontaneity the free flowing line of his *Battle of the Fishes* period. In his later pictures, the diaphanous, multicolored Victorian fantasies match in essence the arabesque of his lacy line (99). These pictures, rich in color and pigment, are also rich in unconscious double imagery, as contrasted with the conscious double images in his etchings of a year or so before.

Originally associated with the *Abstraction-Création* group abroad, Seligmann was eventually drawn to surrealism, which he explores today with sensitivity and imagination. The characters from a personal mythology which he continually evokes are not so much invented as they are materialized. Some are tangled wisps of rarefied vapor which defy nomenclature and others, fantastic ectoplasms and netherworld robots that parade across an endless and uninhabited land. Line, one of his most telling instruments, has greatly increased in effectiveness since he came to America. With it he enwraps and entangles his phantoms, intriguing the spectator to follow the undulating and convoluting rhythms (100). Seligmann has made diligent research into ancient lore and is the author of several articles on myth, fable and the monster. Both he and Masson have published impressive portfolios of etchings made here.

Matta, trained in architecture, is one of several autodidactic surrealist painters, others being Ernst, Masson, Tanguy, Magritte and Lamba. In Paris Matta had done automatic line pictures in colored crayons and after his arrival here, blossomed forth with a profusion of paintings in oil, many of them huge in size. The larger they were, the more pictorially replete, resembling stalactites and precious stones in which South American prismatic colors glow like hot coals. The exposure of his inner perceptions to nature registers in his work a "slow dissolve" — nature in a condition of ecstacy — while his penetrating visual perception X-rays reality. By a fusion of techniques out of painting, *fumage* and photography, the images of dream and of reality are superimposed upon the screen of his canvas where the compositions become

in effect *X-rayographs* (93). Matta at present is in a state of transition, working more casually, in homage to Duchamp.

Although Jacqueline Lamba painted abroad, she has advanced so in her pictorial idiom while here that she may be considered an American surrealist artist. Light is her forte. Contrary to Matta who dissolves form through light, in her paintings form is crystallized by light which is then mirrored back from a thousand facets. Line and color are subservient to the magic of the shimmering and sparkling iridescence which she visualizes as genesis (95).

For the general public, Dali's American activities began the spring day in 1939 when he crashed through a Fifth Avenue store window, landing on the sidewalk and on the front page of almost every newspaper in the country. For all that he had been a yearly visitor to our shores since 1935. Dali's paintings had been from the first the medium by which he fulfilled the need for psychoanalytic release. Today while still in command of the *trompe-l'oeil* technique with which his name is usually associated, his imaginative faculties are forced, so that it would appear that the psychological situations which fed them have lost their power as a stimulus or no longer exist. Moreover he is aware of this and, as an objective observer of his own subconscious processes, has recently declared in favor of other media. His known admiration for the versatile genius of Da Vinci has led to his recent activities in other fields. Within the past two years he has written an autobiography and a novel and is now engaged in probing the secrets of another art, musical composition, preparatory to writing an opera for which he also plans to provide the libretto, the direction and the design.

In 1932 the surrealists commended Dali for the "master impulse" given the movement by his method termed "paranoiac-critical activity," by means of which he interpreted images achieved through "delirious association." The double image is a part of these paranoiac phenomena, defined in Dali's statement (page 140). Perhaps the earliest examples of twentieth-century double imagery are to be found in Duchamp and Picasso. Duchamp in *Yvonne et Magdeleine Déchiquettes*, 1911, drew a shawled head in which the folds of the shawl formed the profile of the second girl. Picasso often painted metaphoric double images: in the analytical cubist picture, *Seated Man*, 1911, the head assumes the shape of a wine bottle and the accordion, represented in many views, resembles an unfolding rose; paraphrasing a stringed musical instrument in his *papier collé*, *Tête*, 1912, the ears of the head become the instrumental sound-holes. Picasso painted many other poetic versions of the double image in this period. But it was Dali who systematically and exhaustively investigated and exploited the double image as an end in itself. Since 1929, he has exercised spontaneous insight whereby changes of image, sometimes as many as six, occur within a given object without change of form. No matter how extensively he may have adopted this and other methods, the rich fertility of his ideas in 1929 has not been surpassed.

The perennial dadaist Duchamp gave up painting in 1923. But still, works from his hand continue to come into being, even though sometimes mysteriously. They are no longer paintings, but an interesting miscellany including *rotoreliefs*, cover designs, *montages* and near-objects. His latest is reproduced in the Spring, 1944, issue of *VVV*, an embossed and colored photograph on which is superimposed a map of the United States cut out on the Canadian border to assume the profile of George Washington, with another profile on the Mexican (recalling the twin profiles of 1911). The picture, *Allegorie de Genre*, adds up to the U.S.A., George Washington, the flag, and done as a symbol of war — gauze and blood — an allusion to *The Spirit of '76*. Duchamp installed the surrealist exhibit for the Coordinating Council behind "thirty miles of string," spinning a veritable maze of cobwebs which symbolized literally the obstacles to be circumvented by the uninitiate in order to see — and understand — the exhibits. He has also been engaged in completing his imaginatively conceived *Boîtes*, begun in France, which contain facsimile reproductions of his life's work in color and half tone, and in miniature objects. The *Boîte* (91) is a device which when

manipulated, retrospectively unfolds the work of Duchamp before the spectator in such a way that it constitutes virtually a composite portrait of the artist's personality.

As artists in our time have revised their entire concepts in painting, some have also revised the idea of the self-portrait, replacing naturalistic portraiture with other forms of interpretation. Duchamp has made an autobiographical record in terms of his *oeuvre*; Breton, a narcissistic self-portrait in the *poème-objet, Portrait de l'Acteur A B dans son Rôle Memorable l'An de Grace 1713*; Ernst in *Vox Angelica* portrays his own wanderlust; Dali's *Illumined Pleasures* (16) presents a pre- and post-natal psychoanalytic study; and Tanning in *Birthday* (74) furnishes a psychological self-estimate.

Nonliteral self-portraits are autobiographies that may be "read" through the medium of their varied and revealing symbolism. In common with twentieth-century art as a whole, they require active spectator-participation: a responsibility is placed on the spectator — that of reading or deciphering the iconography of painting. Broadly speaking, the identification of twentieth-century iconography results in the disclosure of the natural object in relation to its pictorial environment; pictorial environment divorced from object; the symbolic object in relation to its symbolic environment.

By their authority, the artists in exile, many of whom have worked in their respective idioms for a generation or more, have produced that heightened activity which comes from personal contact, besides nurturing in Americans — painters and public alike — a reassuring sense of the permanency of our common culture. Because of this common culture the merging of artists in exile with our painters is a natural consequence of their being here together. This indicates once more the international character of the art of our time, the esthetics of a science- and machine-minded age, a time of dynamic expansion in all fields of endeavor. As there emerges an ever-wider understanding of the importance of basic scientific principles, appreciation for abstract and surrealist art, which may be regarded as the esthetic counterpart of modern science, is being raised to its proper level. Man, manipulating the lever of contemporary culture upon the fulcrum of science, attains the vital balance for twentieth-century art.

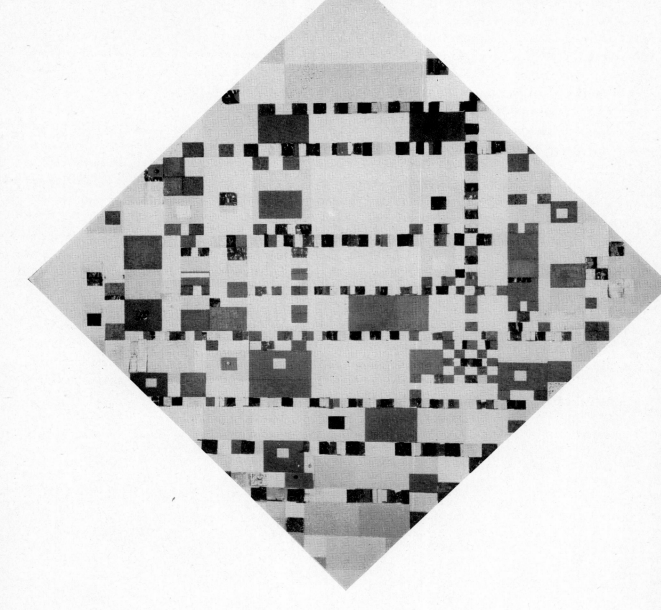

88 PIET MONDRIAN
VICTORY BOOGIE WOOGIE, 1943-44, oil 50 x 50". *Collection Valentine Dudensing.* Born Amersfoort, Holland, 1872. To U. S. 1940. Lived in New York. Died 1944.

— The reality around us as well as life itself is manifested plastically as dynamic movement. Art creates the equilibrium of the factors of this movement, the factors being straight lines in primary colors rectangularly opposed. The accidental is eliminated and pure rhythm is established. — Piet Mondrian, Jan. 6, 1944.

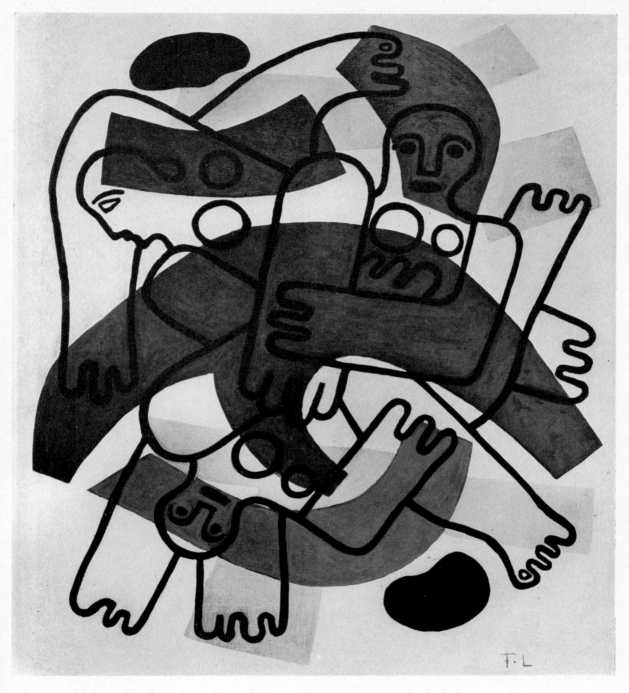

89 FERNAND LEGER
LES PLONGEURS CIRCULAI-
RES, 1942, oil 50 x 58″. *Collection
Valentine Gallery*. Born Argentan,
France, 1881. To U. S. 1940. Lives in
New York.

— The relationship of human bodies in terms of pictorial dynamism prompted
Les Plongeurs Circulaires, one of several variants on the "cycle of the divers."
For this modern motive I might have gone to any sport, but only divers could
enable me to realize a new deep space without the aid of traditional perspective.
The concept of forms like birds and clouds which rotate out of a fulcrum is a
part of the *new realism* of our time. The picture may be hung on any one of
its four sides. Mr. Janis had the idea to have the picture revolve — to make of it
a mobile painting. Why not? — Fernand Léger, 1944, translated by Mlle. Roux.

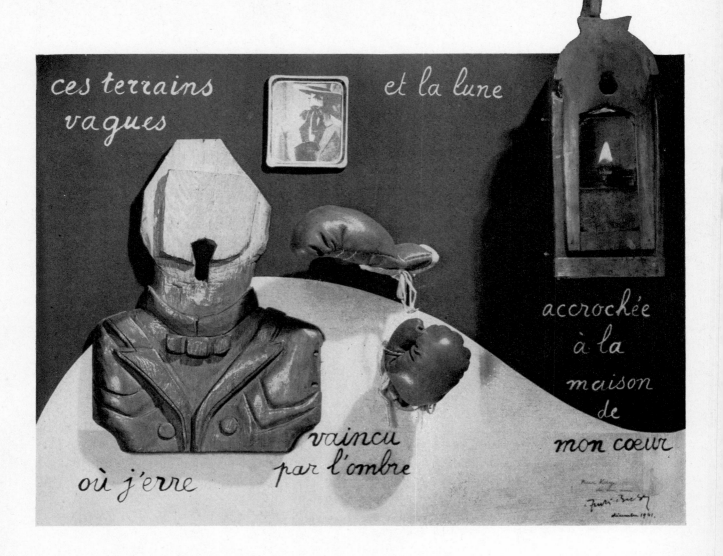

ces terrains vagues

et la lune

accrochée à la maison de mon coeur

où j'erre

vaincu par l'ombre

90 ANDRE BRETON
POEME-OBJET, 1941, wall object. *Collection Mr. & Mrs. Yves Tanguy.* Born Tinchebray (Orne), France, 1896. To U. S. 1941. Lives in New York.

— In the spirit which Rimbaud wrote "*des silences, des nuits,*" and fixed upon "*des vertiges*" this object expresses an *anguish*, a dramatic apprehension of the motive not elucidated at the moment of its conception but which has since become clearer to me.

The personage on the left, the terrifying picture in the frame, the curve which divides the panel outlining a halfhead of a reclining mannikin: so many variations on the subject of the *lost head*.

Still all idea of fight is not abandoned, as shown by the boxing gloves, one in a defensive position in the shadow, the other in a position of attack in the light. A cavity replaces the mouth suggesting a keyhole and the inscription concerning the moon alludes to an object of my astrological theme on birth. — André Breton, 1944.

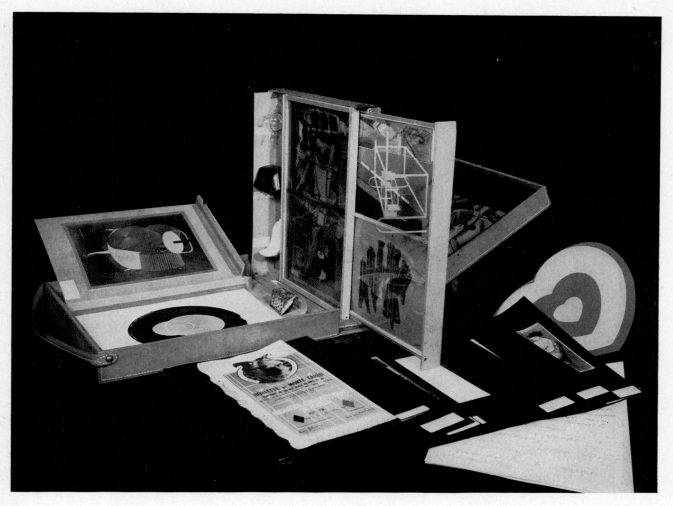

91 MARCEL DUCHAMP
BOITE-EN-VALISE, 1941-42, object 16 x 15″. *Collection*
Art of This Century. Born Blainville (Seine Inférieure), France,
1887. To U. S. 1942. Lives in New York.

— Idea of Fabrication: If a thread (straight and horizontal) a meter long is dropped from a
height of a meter onto a horizontal plane, its chance-shape gives it a new unit of length. —
Selected by Marcel Duchamp, 1944, from his notes on *The Bride*

92 MARC CHAGALL
A MA FEMME, 1933-44, oil 51 x 77". *Collection the Artist.*
Born Vitebsk, Russia, 1887. To U. S. 1941. Lives in New York.

—If it took eleven years to make and to change this picture, how many years should I need to explain it in words?—Marc Chagall, 1944.

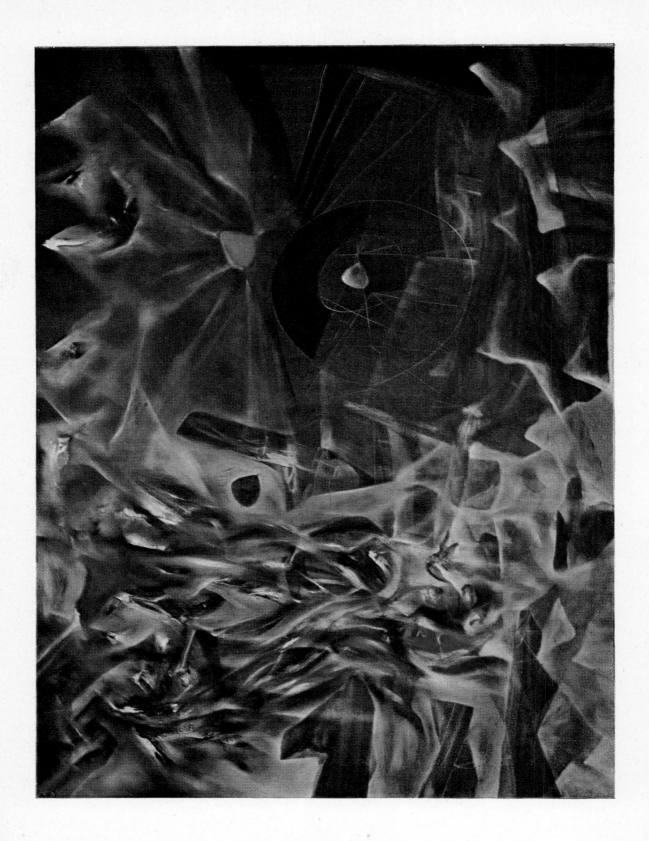

93 ROBERTO MATTA ECHAURREN
THE DISASTERS OF MYSTICISM, 1942, oil 38 x 51".
Collection Mr. & Mrs. James Thrall Soby. Born Santiago, Chile,
1912. To U. S. 1939. Lives in New York.

— For me it is a structural sense of life as one has a sphere-like conception of the earth . . .
Man inventing as nature invents, is like participating in advance in a future time . . . This
experience comes to our senses by straight perception, the insistent perception of the phenomenal
that we use as a law of reference. — Matta, from "School of Paris Comes to U. S.," *Decision,*
Nov.-Dec., 1941.

94 MAX ERNST
NIGHT AND DAY, 1942, oil 40 x 62". *Collection Lt. Wright Ludington.* Born Brühl, Germany, 1891. To U. S. 1941. Lives in New York.

—*Night and Day*, or The Pleasures of Painting: To listen to the heartbeats of the earth. To yield to that fear which comets and the unknown inspire in men. To put out the sun at will. To light the searchlights of night's brain. To enjoy the cruelty of one's eyes. To see by the soft gleam of the lightning. The majesty of trees. To invoke the fireflies . . .—Max Ernst, 1944.

95 JACQUELINE LAMBA
IN SPITE OF EVERYTHING, SPRING, 1942, oil. *Collection Norlyst Gallery.* Born Paris, 1910. To U. S. 1941. Lives in New York.

— The object is only a part of space created by light. Color is its non-arbitrary choice in transfiguration. Texture is the crystallization of this choice. The line does not exist, it is *already* form. Shadow does not exist, it is *already* light. — Jacqueline Lamba, 1944.

96 AMEDEE OZENFANT
ARIZONA #1, 1938-44, oil 39 x 30".
Collection the Artist. Born St. Quentin,
France, 1886. To U. S. 1938. Lives in
New York.

opposite
97 YVES TANGUY
LE TEMOIN (detail), 1940, oil. *Col-
lection Mr. & Mrs. Le Ray Berdeau.*
Born Paris, 1900. To U. S. 1939. Lives
in Woodbury, Connecticut.

— As far as I am aware, my nature is two-sided: a strong need for calm, har-
mony, discipline (my purist painting), and an equally exacting need of
dynamism, abundance, full freedom. In Arizona I found powerful dynamic
rocks contrasting with calm and wise Indian villages. I tried in creating this
composition to satisfy simultaneously my two opposite "natures." — Amédée
Ozenfant, 1944.

— I expect nothing from reflection but I am sure of my reflexes. — Yves Tanguy,
from *In the Light of Surrealism* by Georges Hugnet, 1934.

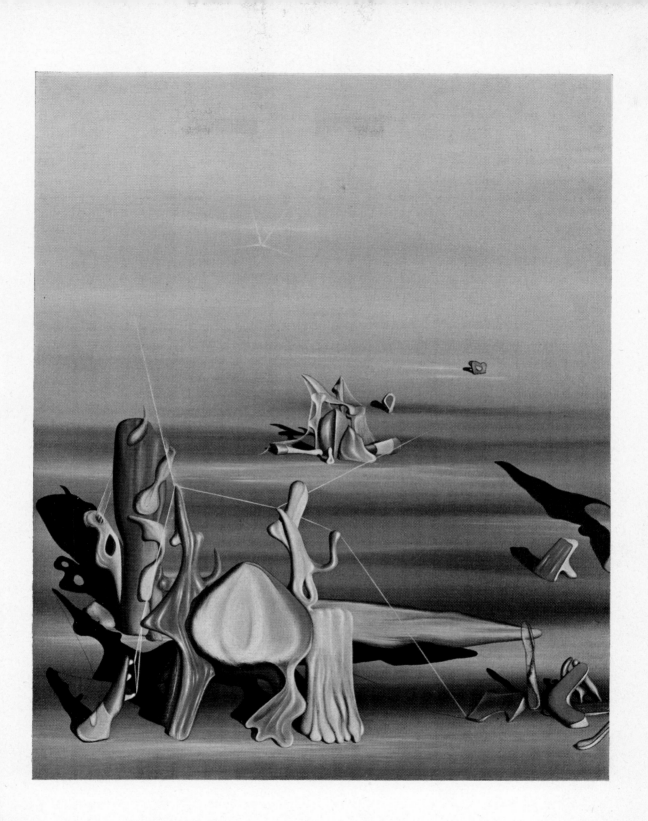

98 SALVADOR DALI

SPAIN, 1938, oil 36 x 23½". *Collection Edward James.* Born Figueras, Catalonia, 1904. To U. S. 1938. Lives in Del Monte, California.

— The way in which it has been possible to obtain a double image is clearly paranoiac. By the double image is meant such a representation of an object that is also, without the slightest physical or anatomical change, the representation of another entirely different object, the second representation being equally devoid of any deformity or abnormality betraying arrangement. — Salvador Dali, *Le Surréalisme au Service de la Révolution,* I, 1930.

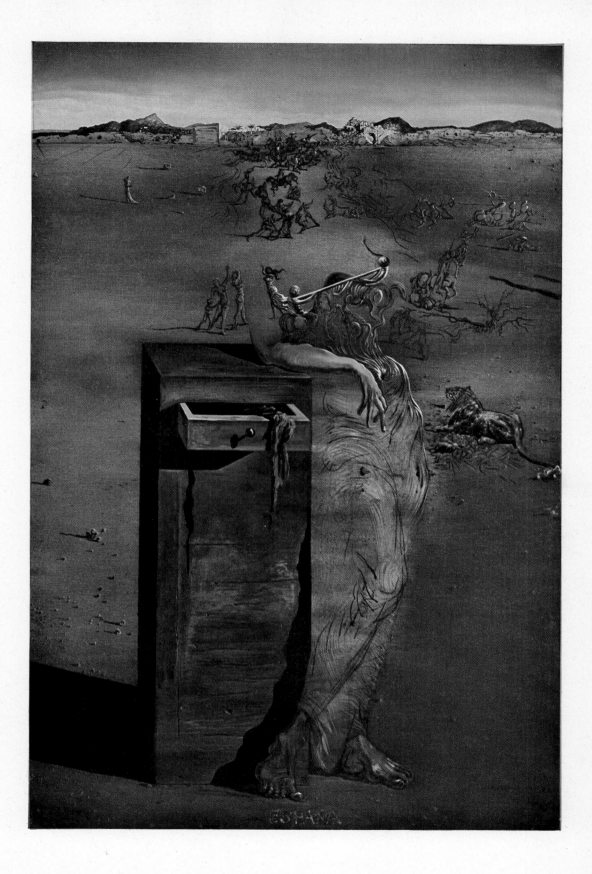

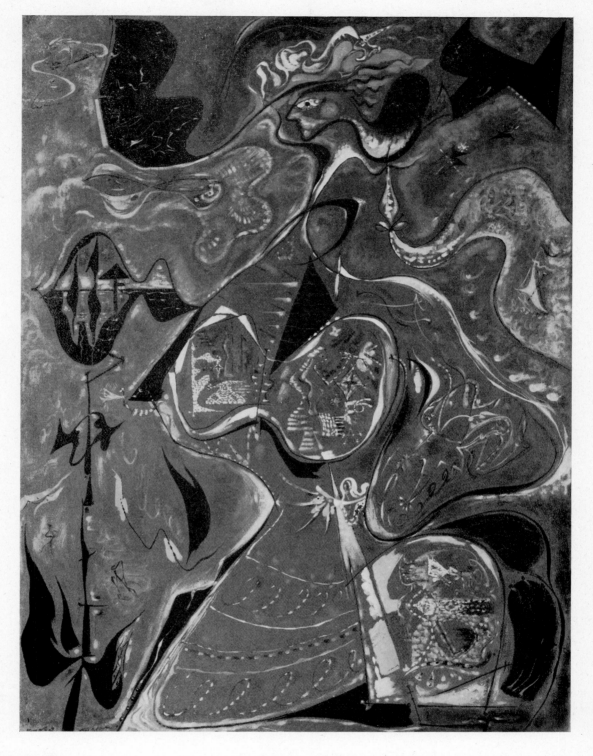

99 ANDRE MASSON
LA BELLE ITALIENNE, 1943,
oil 57 x 42″. *Collection Lt. Wright Ludington.* Born Balagny, France, 1896. To
U. S. 1941. Lives in New Preston, Conn.

— To seek the extraordinary, or to shun its appeal, is not the question. A picture
always proceeds from the imaginary . . . Its reality is the *matière* of which it
is composed, but what it expresses is necessarily super-real. And I might add
that whatever the motive of his work, it is always to the imagination of others
that the artist speaks. — André Masson, translated by Curt Valentin, 1944.

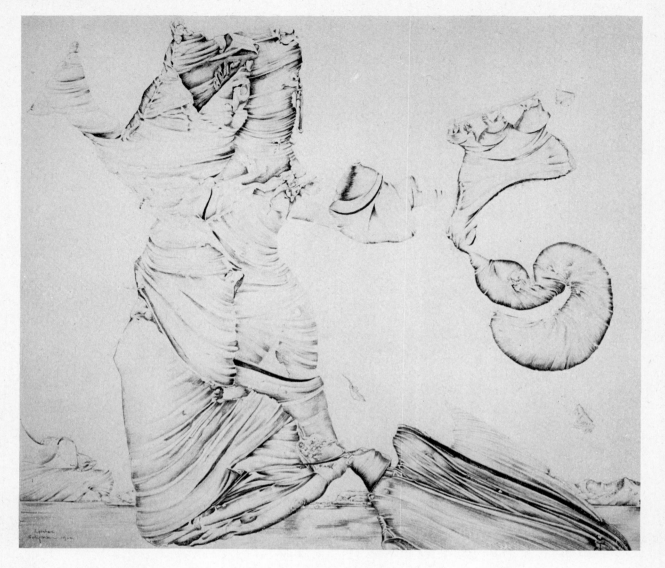

100 KURT SELIGMANN
DEPARTURE, 1942, crayon 39½ x 45½". *Collection Durlacher Brothers.* Born Basel, Switzerland, 1900. To U. S. 1938. Lives in New York.

—The drawing in *Departure* is not automatic in the usual sense. It derives from an *a priori* image. There are three elements: man, animal, earth. The forms are held in suspense by contrary currents, like a vanishing column of smoke on a clear, calm day.— Kurt Seligmann, 1944.

INDEX OF ARTISTS